Historic
Plantations
of
ALABAMA'S
BLACK BELT

Historic
Plantations
of
ALABAMA'S
BLACK BELT

JENNIFER HALE

THE
History
PRESS

Published by The History Press
Charleston, SC 29403
www.historypress.net

Front cover images: Kirkwood Mansion, Eutaw, Greene County. *Courtesy Chip Cooper*;
Kirkwood Mansion column. *Courtesy Chip Cooper*; Reverie Mansion knot garden; Reverie
Mansion ladies' parlor.
Back cover images: Bluff Hall fireplace. *Courtesy Library of Congress*; Kenworthy Hall staircase.
Courtesy Library of Congress; Gaineswood domed ceiling . *Courtesy Library of Congress*; River
Bluff House porch.

All images by and courtesy of author unless otherwise stated.

First published 2009
Second printing 2009

Manufactured in the United States

ISBN 978.1.59629.669.5

Library of Congress CIP data applied for.

Dedicated to the Old South.

May we learn from her story: both to emulate her gracious essence and to extol her moral triumphs of character and determination; let us also heed her mistakes against humanity and moments devoid of spiritual guidance.

CONTENTS

FOREWORD

For more than thirty years, I have traveled the various back roads of a region that has inspired my most creative work. The area of Alabama called the Black Belt has drawn me into its mysteries, beauty and tragedies and has never let go.

From my very first trip years ago to my most recent adventure this past month, my mind always goes to the past, present and future of this region, an area that has been greatly admired and also greatly misunderstood.

Past: Who lived in these homes? What kind of lives did they have? How did they live in this climate and endless more questions.

Present: Who occupies this home today? Do they actually live here? How are they keeping it up? The house is in such disrepair—who will save it?

Future: Will we be able to preserve this proud architectural heritage?

All of these questions have been the moving force behind my extensive photography of the Black Belt. My travel usually takes me right, left and right, and then I get lost and rediscover.

One winter day, following my plan, I came on a very old and dilapidated dogtrot covered in kudzu vines. Any other time of year, the foliage would have made the home impossible to find. Walking up to it, I was struck by how beautiful this place must have been. The vines covering it gave it such a haunting look, but what got me excited was a child's dress hanging on a nail next to the front door. Who lived here, when, how? All the questions rushed over me. In turn, how I would photograph the various structures would be determined by thinking over the many questions that popped into my head.

FOREWORD

Through the years, I have shot all the major styles and periods of architecture, as diverse as the simple dogtrot to the elegant Palladian mansions. I have found the Black Belt area to have the most variety in all of Alabama. My love and interest in the homes is evident in the amount of images I have used in my photography books.

This work by Ms. Hale—which tells the stories of some of these homes, many of which I have photographed in the past—is important because it helps us to see the people who lived there, understand their lives and how they passed the house on to another family so that the house and its story continued to live. Through these pages, Jennifer helps people to see these architectural gems in a more complete and human way. She expounds not only on the actual building and design of these structures, but also cleverly wraps them in a tapestry of the families' lives of yesterday who struggled to build them and those of today who sacrifice to keep this architectural history alive.

What about the other dwellings that have been ignored by time, out of sight and conscious memory because of their remote locations? Many have said that every year we lose one third of all existing structures.

My hope is that this book plays a role in helping pass on the urgent message that we have a duty to preserve what came before us, whether it be the magnificent mansion with a history of being maintained and restored or the abandoned home falling down and still clinging to a slight glimmer of hope for survival.

Chip Cooper
Tuscaloosa, Alabama
April 2009

Acknowledgements

S pecial thanks to Kay Beckett, Teresa Beeker, Al and Danky Blanton, Frank Chapman, Dr. Edward Childs, Eleanor Cunningham, Arthur and Bess Collias, Chip Cooper, Mary Gogbold, Everett Hale, David and Pam Harmon, Sara Harris, Brock Jones, Bruce Lipscomb, Von McQueen, Wilson Moore, Manera Searcy, Garland Smith, William Spencer III, Richard and Linda Williams, Jack and Jackie Woods and Ouida Starr Woodson.

INTRODUCTION

Alabama is home to numerous historical plantations offering a telling glance into the South's storied planter roots. An especially impressive collection of these antebellum homes dot the state's Black Belt, a crescent region stretching across the south-central part of Alabama, named originally after its dark, fertile soil. The wealth, influence and grandeur of Black Belt plantations peaked in the late 1850s and early 1860s, until the War Between the States.

In the early 1800s (as mechanization came of age during the textile boom), factories in the northern United States and Europe began purchasing increasing amounts of cotton at higher prices from the South. The textile boom initiated the cotton boom, which generated the plantation boom of the 1840 and '50s as a soaring number of planters began looking for available, fertile land to farm. Cotton was known as "white gold," and everyone wanted a part of it. In Wilcox County alone, fifty boat landings sprung up along the Alabama River to load cotton onto boats for the two-day trip to the port of Mobile. Wilcox County was one of Alabama's wealthiest counties, with most businesses closing at noon every Thursday so folks could attend the slave auction in Camden. Some estimates say that the Deep South was exporting two-thirds of the world's cotton supply at one point. Cotton was certainly king, and not just for the planters who grew it. Demand was high in Europe and on the northeast coast of America. In return, the newfound wealth in the South allowed for the purchase of supplies and machinery from above the Mason-Dixon line and luxury items from across the ocean.

Entrepreneurs began pushing into much of the Deep South from places like Georgia, Virginia, South Carolina and especially North Carolina. These early residents are credited with influencing much of the architecture of antebellum plantation homes ("ante" meaning before, "bellum" meaning war).

Plantations were not always anchored by a grand home. Some families chose to live in simpler, log cabin–type accommodations. Other families renovated original cabins and structures as their financial statuses allowed. In the antebellum era, people called it "improving a house." This book features the grandest, most romantic and, on occasion, most improved homes of the time. Some of them began life as much more humble structures, eventually becoming improved to the point that they set the standard for the homes to come.

Today, few remain out of what was once a landscape of glorious architectural treasures. Their survival is a true testament to their excellent craftsmanship, as well as the passion and devotion of those persons who have refused to let the lights and stories of these homes and their residents be extinguished.

Chapter 1

BELVOIR

Pleasant Hill, Dallas County, 1825

Tucked just behind a small line of trees in a town appropriately called Pleasant Hill sits an antebellum mansion of the grandest stature, both architecturally and historically.

Belvoir (pronounced Bel-vwah) means "good site" or "good land" in French. Georgia native Reuben Saffold II and his wife, Mary Evelyn Phillips, built the original Belvoir in 1825—the date inscribed on a water spout. However the home's present owners, the Colliases of Boston, do not believe that the house was completed to its modern-day state until the 1840s because of some distinct architectural characteristics that became vogue courtesy of the cotton crops' prosperity—details such as Belvoir's broad front porch framed by six columns, as well as its impressive ceiling medallions and wide crown moldings.

The story of Belvoir's beginnings dates back all the way to July 27, 1813, at the Battle of Burnt Corn, which unfolded near present-day Monroeville, Alabama. During that first battle of the Creek Indian War, then private Saffold found himself engaged in a desperate battle for survival against a company of Indians, led by the chief of the Red Stick faction of the Creek Indians, Peter McQueen. The chief, a fierce warrior, was the son of an Indian squaw and Scottish trader John McQueen, who arrived in America as a teenager after sneaking onto a British ship just before it set sail for the United States. Legend has it that Peter McQueen played the bagpipes at every battle in which he fought, and history tells us that he is responsible for the brutal Fort Mims massacre north of Mobile that left five hundred settlers dead. Saffold and McQueen may or may not have come face to face

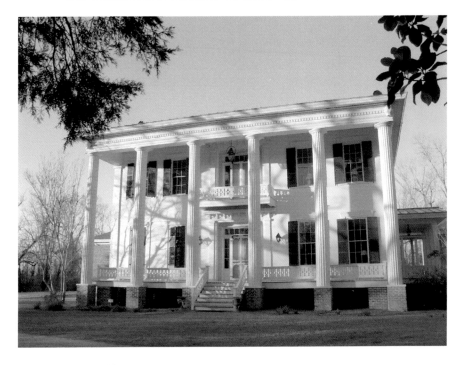

Belvoir, January 2009.

on the battlefields of Burnt Corn, but some Pleasant Hill locals insist they did, recounting stories of a bitter feud that sparked between the two men in the heat of battle. Unfortunately, the true details of that alleged grudge now belong solely to the past, but we do know that, from then on, the two families' lives would intertwine for decades to come.

At some point after the Battle of Burnt Corn, Saffold was searching for the perfect setting for his home and plantation. An Indian scout named Sam Dale helped Saffold and showed him several prime pieces of land, Indian land, including the tract where Belvoir now sits. Saffold fell in love with the property that he eventually came to call his own, becoming especially attached to the three valuable springs on the land. The Indians of the area were not pleased with his decision to showcase some of their finest real estate, and when Peter McQueen's cousins bought Belvoir in the 1960s, Carroll McQueen reportedly told his family, "We finally got a little of our land back from those Saffolds."

After life in the military, Reuben Saffold II went on to become a well-liked, successful attorney who helped write Alabama's constitution in 1819

and then became a circuit judge. In 1832, Saffold was appointed to one of the seats on Alabama's Supreme Court, and in 1835, he became the state's third chief justice. Saffold's portrait and chair still today sit in the Alabama Supreme Court building.

Sometime in the late 1830s, Saffold was traveling up the Alabama River on a steamer when he met Philip Gosse, a painter and naturalist from England who had come to explore the New World. Saffold was impressed with Gosse and hired him to come to Belvoir to teach his children. While at Belvoir, Gosse documented his experiences in a collection of letters he sent back to England. In those letters, Gosse described an amazingly beautiful world, full of fantastic flora and fauna. Those letters were eventually made into a book entitled *Letters From Alabama* published in 1859.

As impressed with Alabama's natural beauty as Gosse was, he was even more disgusted with the slavery he witnessed at Belvoir. (Reuben Saffold is remembered to have been one of the more gentle and fair slave owners.) After eight months, Gosse left Belvoir, unable to stomach the site of constant human bondage. He returned to England, where he became a well-known author, especially concerning nature.

Meanwhile, life at Belvoir continued most productively. In 1840, records show that Saffold hired John Getson Traylor as overseer of Belvoir for an annual salary of $550, six hundred pounds of pork, one hundred pounds of sugar and fifty pounds of coffee plus feed for Traylor's horses.

In 1841, Belvoir produced a cotton crop of seven thousand pounds; that year cotton was selling for around ten cents per pound.

Saffold seemed to prefer private law practice to public life. In 1843, he declined a second appointment to the Alabama Supreme Court. However, on occasion, Saffold did find it necessary to return to Montgomery, and when he did, he stayed at the home of Carroll McQueen's great-grandfather, one of Peter McQueen's cousins. How the two knew each other is another secret that history has kept firmly hidden.

Reuben Saffold died of a stroke on February 15, 1847. He and Mary were the parents of ten children, many of whom also enjoyed great success. In particular, son Benjamin J. Franklin Saffold held many of the same offices as his father, including delegate to the state constitutional convention and a justice on the Alabama Supreme Court. However, B.J. Saffold, as he is often referred to, lived in very different times. He and his father were Democrats before the War Between the States. After the war, B.J. helped organize the Dallas County Republican Party while he was serving as mayor of Selma.

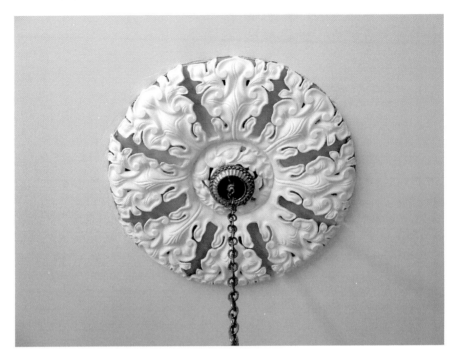

Ornate plaster medallions on Belvoir's ceilings.

The year 1867 was not a good time for a Republican to try to govern Selma, and many locals detested B.J. Saffold. He is believed to be buried in the family cemetery at Belvoir near his father and mother, but no one knows which grave belongs to whom because the Saffold family decided to remove all head markers and even the fencing around the graveyard for fear that someone would desecrate B.J. Saffold's grave if they knew which one it was. The graveyard remains unmarked today.

Reuben and Mary's youngest daughter, Elizabeth Evelyn (better known as Eliza), was a strikingly beautiful girl. Her parents sent her to Europe when she reached the appropriate age for her grand tour. While in France, Eliza met and fell in love with one of Napoleon Bonaparte's lieutenants. She wrote her father, asking for his permission to marry. Reuben Saffold not only withheld permission but also ordered Eliza to return home immediately. She spent the rest of her life in her room at Belvoir, dying a lonely spinster. Legend has it that the dark spots still visible today on the wood floors in Eliza's bedroom are her teardrops, and locals suspect that she has never truly left Belvoir. Pleasant Hill is full of stories about strange sounds and happenings in Eliza's

Belvoir

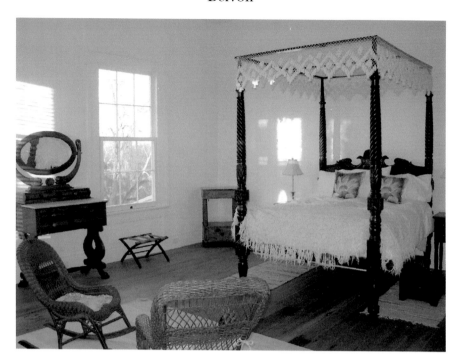

Eliza's bedroom.

bedroom, such as slamming doors, as well as inexplicable happenings around Belvoir, like missing ladders being found tucked into strange places when the renovation crew had stacked all of their equipment in a separate area.

Current owners, Arthur and Bess Collias, experienced the phenomena for themselves not long after they bought Belvoir. Bess Collias relates:

> We were both sitting downstairs by ourselves when we heard this rumbling above us, like someone dragging a heavy piece of furniture across the floor. The noise started at one end of Eliza's room and moved across the ceiling to the other side. When we went upstairs to look, nothing was out of place, nothing had been moved. There wasn't even much furniture up there because we had just moved in. We don't believe in ghosts, but we still have no idea what made that noise.

Eliza has never caused any detrimental problems, and her ghost, whether real or imagined, seems to have been effective at preserving Belvoir. Like so many grand antebellum mansions, Belvoir sat empty for nearly three

Gas lanterns ordered from New Orleans, Lousiana.

decades, but unlike most of its abandoned contemporaries, Belvoir was never vandalized or stripped down during those lonely years. "I think it's because most locals truly believe Eliza still lives here. They were afraid to come in," says Arthur Collias. A stunning portrait of Eliza still exists today. It belongs to Marion Saffold Oates Charles, a legendary hostess and socialite who lives in Washington, D.C., and Newport, Rhode Island. "Oatsie," as friends call her, is the granddaughter of Alabama governor William Calvin Oates, who served from 1894 to 1896. She grew up in Montgomery and recalls playing at Belvoir as a child. She and the Colliases met by accident at a dinner for the National Trust for Historic Preservation.

Through the years, Belvoir was also owned by the Masons—a Catholic family out of Birmingham who used Belvoir as a hunting lodge—then in the 1960s by the McQueens, who were distant relatives of the Masons. The Masons put Belvoir up for sale, because as the Civil Rights Movement raged just a few miles away in Selma, owning an antebellum plantation proved to be a difficult task because of the racial tensions of the time. Selling an antebellum mansion at that time proved to be an even more daunting challenge, and the Masons contacted anyone who could be considered family to let it be known they were dropping the price substantially and wanted a quick sale. Birmingham foundry operator Carroll McQueen and his wife, Connie, bought Belvoir and its five hundred acres for $50,000.

The McQueens and their two sons, Von and Mike, spent many years splitting time between Birmingham and Belvoir. "I absolutely became enamored with Belvoir and the world down in the Black Belt. I never wanted to return to Birmingham. It was so colorful and alive compared to what I considered the dull suburbs of Mountain Brook," says Von McQueen in a genteel Southern accent reminiscent of a time past. He was fifteen when his parents purchased Belvoir, and although much had changed since Saffold's day, much was still the same.

One of the descendants of former Belvoir slaves still remained and worked for the McQueens—Ben Walton, better known as "Uncle Ben." He told the McQueens stories of how, before Belvoir was built, his grandfather rode on oxen from the banks of the river as the animals dragged the columns for the home off the steamboat and up to the construction site. Uncle Ben's father was a house servant at Belvoir who, in preparation for breakfast for the ladies of the home, brought goat cheese up from the springs every morning, where it was being kept cool. Later, the McQueens hired Uncle Ben to help look after Belvoir when they weren't there and especially to exercise the Tennessee walking horses that they kept on the property. "Uncle Ben was one of the

most dignified, gracious, proper gentlemen one could ever hope to meet. Everyone knew it and respected him. He'd ride those horses through town every day, sitting tall, tipping his hat to everyone. Folks would step out on their porches just to greet him," remembers McQueen, who is now a Baptist minister and a college professor.

Uncle Ben and many of the slaves who preceded him at Belvoir were of a smooth copper color, much lighter than most of the slaves at other nearby plantations. McQueen says that this is because Saffold bought his slaves at the port of Mobile from Arab slave traders, who impregnated some of the African women who they were trying to sell.

Uncle Ben's approach to problem solving issues in his family, especially with his brother, is one of the memories that will forever live on in Von McQueen's mind:

He and his brother never spoke a cross ugly word, not to each other, not to anyone. When they had a problem, they would sit up together all night in front of the fire after the day's work was done, reading the Bible and finding Scriptures that could offer them guidance in what to do for that particular situation.

McQueen is still in touch with some of Uncle Ben's relatives.

Miss Ida Townes is another influential person in McQueen's life. Miss Ida was the daughter of a black preacher whose master gave him his freedom to go evangelize across the countryside. She came to Belvoir by way of marriage. First the Masons employed her, and then the McQueen's hired her to run the house when they took ownership. "She ruled that plantation, believe you me," smiles McQueen. Miss Ida knew much about Belvoir's history, as her highly regarded family is from Pleasant Hill and still lives there today. Miss Ida judged the plantation not in years but by who owned it when. "She would tell stories about how the Masons tried to convert her to Catholicism, and how, after living through the Great War [the Civil War] her parents thought so poorly of the Yankees, always telling her they were much meaner than any Southern white ever was," says McQueen.

Those were grand years for Belvoir, full of happiness, laughter, friendship and grand parties. The details of Belvoir's soirees appeared regularly in society columns in Birmingham. "Mother and Father kept Belvoir lively, socially and politically," says McQueen, who will always remember one party in particular:

Belvoir

Mother was hosting a lawn party, a political fundraiser of sorts, for an old southern state lawmaker named Givan. It was a grand party, and she had girls wearing antebellum dresses on hand to greet the guests as they arrived. When Senator Givan came through the gates, he got teary and asked mother, "Don't you know it's against the law to live like this anymore?"

The McQueens raised cattle on Belvoir's pasturelands, animals that are rumored to have led to Mrs. McQueen's permanent departure from Belvoir. The story goes that Mrs. McQueen was an avid gardener who meticulously groomed Belvoir's grounds. One day her husband's cows broke through the pasture fence and dined on all of Mrs. McQueen's delicate flowers. She was so upset and disgusted that she never returned. While part of that may be true, the more accurate picture likely has more to do with age and time. As the McQueens grew older and couldn't handle the trips to Belvoir or the plantation's upkeep, they contemplated selling their beloved plantation. Mrs. McQueen, however, was strict and firm about who should and should not have the home. She rejected an offer from a group of Japanese business executives who wanted to turn Belvoir into a hunting club, reasoning that only Americans should own Belvoir. Mrs. McQueen also turned down an offer from a Georgia man who wanted to dismantle Belvoir and take it back with him across the state line. Mrs. McQueen staunchly believed that Belvoir belonged to the people and land of Pleasant Hill.

The McQueens found the owners that they were looking for in the late 1990s when the Colliases came to look at Belvoir. "I always thought it would be so wonderful to own a plantation home, but I never thought it was something that would be within my reach," says Bess Collias, a native of Mobile. Bess graduated in microbiology from Spring Hill College before marrying Arthur Collias and moving to Boston, where she specialized in infection control for hospitals. The Colliases were originally thinking about buying a plantation home in Camden, until Bess laid eyes on Belvoir: "It was this distinct grey color. It just looked so forlorn, like it was saying, 'Love me, love me.'" Despite the shared vision for Belvoir, negotiations still took a year. "It was worth it because I knew it was exactly what she wanted," says Arthur Collias, a metallurgical engineering graduate of the Massachusetts Institute of Technology (MIT), who developed a new technology for orthopedic surgeons that was later bought by Johnson & Johnson[R].

The couple has launched a major renovation of Belvoir, while being mindful to keep the home as architecturally pure as possible. "When we

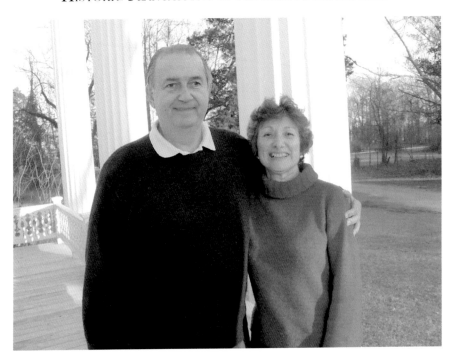

Arthur and Bess Collias, current owners of Belvoir.

retired in the early '90s, we needed to find something to keep ourselves out of trouble. We so far have not succeeded—we found the perfect money pit," laughs Arthur Collias. The couple has left Belvoir's classic four-over-four design unaltered, instead adding a new closed-in porch off the back that leads to a separate kitchen and breakfast nook with all the modern conveniences. The Colliases wanted Belvoir to remain as true to period as possible. Previous owners had already installed one line of plumbing in the original structure. The Colliases used that piping to dictate where to put the upstairs master bathroom and, therefore, master bedroom so that no extra plumbing would need to invade the home's walls.

Bess Collias was extremely conscious of Belvoir's intricate plaster ceiling medallions: "I didn't want a waterline anywhere near them, just in case it broke," she explains. Belvoir still boasts all of its original woodwork: trim, the mahogany banister and the heart pine floors that the Colliases had stripped of modern-day finishes and simply waxed to regain their original look. They split time between Boston and Pleasant Hill, spending their retirement years exploring and preserving all that history has to offer in both areas. The couple

allows nearby Morgan Academy to use one section of Belvoir's five hundred acres for hunting trip fundraisers; a local farmer leases another portion. The Colliases have also opened up Belvoir's pasturelands to archaeological digs. Students and professors from the University of Alabama found nails and porcelain predating the Civil War, as well as a double row of slave quarters in the pasture. "This has been such an adventure for us. We had no connection to anything like this. It's been fun," says Arthur Collias.

The residents of Pleasant Hill now seem to feel a connection to the Colliases as well. The couple has been greeted with open arms and celebrated for their efforts to restore and preserve Belvoir. "The people here are so warm and welcoming. They make us feel like this has been home for years. It touches me so much when someone comes up to me and says they just want to thank me for saving Belvoir. This is a home so much of the community feels invested in," says Bess Collias.

Von McQueen, unable to bid Belvoir a complete farewell, continues to own and use the plantation overseer's house. The home, the memories it fosters and the town are precious jewels that he's not ready to turn loose. "I think about how much I have lived through here, how much I've been lucky enough to see," he says. "For years I didn't realize what a treasure I was living in. Now, it's amazing. The old ways are almost all gone, completely evaporated in such a short number of years." McQueen may not be able to hold on to the remnants of the nostalgic Old South, but as they dissolve before his eyes, he's determined not to miss any of the moments that are left.

Belvoir was added to the Alabama Register of Historic Places on November 2, 1990.

Chapter 2

THORN HILL

Watsonia, Greene County, 1833

Perched high atop one of Greene County's most impressive knolls, Thorn Hill stands tall and proud, a quintessential calling card of the antebellum South with roots winding directly back to England.

The home's builder was Colonel James Innes Thornton, a man of superior familial standing whose forefathers came from the Thorn-On-the-Hill estate in England. When Thornton's relatives moved to America about 1640, they built Fall Hill Plantation in Fredericksburg, Virginia, right on the banks of the Rappahannock River. The descendants of this family, through marriage, include Colonel James Innes Thornton's cousin, General George Washington. Colonel Thornton was born at Fall Hill, and after earning his law degree from what is now Washington and Lee University, he set out for Alabama on horseback, his law books in tow.

An early success, affable in disposition and tall in stature, Colonel Thornton read law in Huntsville, was admitted to the bar and by age twenty-four had become Alabama's secretary of state. Colonel Thornton's abilities were admired by many, including the governor of Alabama, who in 1825 tapped Thornton to greet the Revolutionary War hero General Marquis de Lafayette at the Georgia line. The general was visiting Alabama on his tour of the United States. As Thornton was escorting Lafayette to the then state capital of Cahaba, he stumbled on a treasure perhaps greater than his current honor of escort: the perfect location for the next great Thornton home.

Perhaps it was the fertile soil of the land, nourished by the two rivers it sat sandwiched between (the Tombigbee and the Warrior), or maybe it was

the magnificent view—one can see four counties from Thorn Hill: Greene, Sumter, Marengo and Hale. Whatever it was, Thornton made immediate arrangements to purchase eighty acres for about $1.25 per acre. Through the years, Thornton acquired more acreage, eventually owning 2,600 acres. He then married Mary Amelia Glover, whose brother, William Allen Glover, built Rosemount Plantation on the land neighboring Thorn Hill. The Thorntons had two children by the time Mary tragically passed on.

At that point, Thornton visited his native Virginia and returned to his Alabama homestead with his new bride, Anne Amelia Smith, who was twelve years his junior, as well as several friends from Virginia. Legend says that all of these men knew, on some sort of personal level, General Washington and the grand homes of Virginia such as Mount Vernon and Kenmore. These were houses that they intended to recreate for themselves to some extent in Alabama. According to the book *Stars Fell on Alabama* by Carl Carmer:

> *They made a long gay caravan traveling southward from Old Dominion, the gentlemen riding beside their wives' carriages, behind them the mounted overseers bringing on the wagon train filled with household goods and farming tools and slaves...every family built a house on a hill—so that each hill of a curving chain was crowned with a Virginia home.*

The grandest was arguably Thorn Hill. In 1833, Thornton and his new bride quickly settled into the challenge of building their grand mansion, which they christened Thorn Hill. The couple is believed to have enlisted the services of William Nichol, the architect who designed the new state capitol building in Tuscaloosa when Alabama's fourth governor, John Murphy, moved the seat of government from its original location in Cahaba. Nichol and Thornton used the pattern from Venetian architect Andrea Palladio (which was also used by Thomas Jefferson when designing the pavilion at the University of Virginia), as well as some influence from Thornton's childhood home, Fall Hill.

Thorn Hill slaves used cypress, cedar, walnut and heart pine cut from the nearby woods to construct the elegant Greek Revival lines of the mansion. The grand staircase inside is mahogany. Outside, fluted Ionic columns frame a deep porch perfect for gazing out over the landscape, lush with beautiful gardens of Lombardy oaks, boxwoods and roses. Family legend says that Anne Thornton brought an impressive supply of cuttings with her from Virginia, even storing some in her slippers tied beneath her carriage floor. At

Thorn Hill

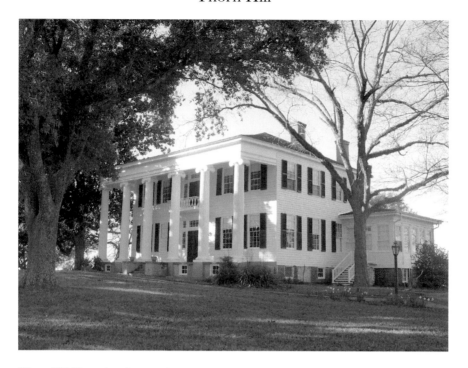

Thorn Hill Plantation, January 2009.

one point, a plethora of notable antebellum buildings were erected up close to the "big house," including Free Hope Church—originally built for Thorn Hill's slaves—as well as a schoolhouse used to educate Thornton's children and those from other nearby plantations.

The family converted the schoolhouse into a weaving room to make Confederate uniforms during the War Between the States. That schoolhouse still occupies that same plot of ground on the plantation, the oldest plantation schoolhouse in Alabama in its original location. Now, it's surrounded by oak trees dating back 210 years, and it is used to house detailed genealogical information about Thornton's many descendants.

Thorn Hill's rockery sits just to the west of the schoolhouse. The large rock perched on the hill provided excellent views of the plantation fields and was therefore one of Colonel Thornton's favorite spots. He often sat there inspecting his fields and his workers. This is also the spot where, years later, he watched his beloved daughter Kate (Katherine Marshall Thornton) disappear from view for the final time after she left Thorn Hill to move to Nevada with her new husband, Harry Innes Thornton, her first cousin.

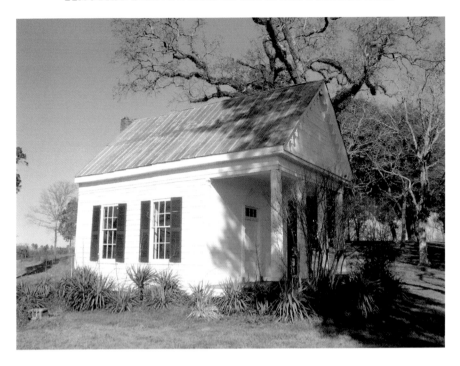

Thorn Hill Schoolhouse, January 2009.

She died in 1870 at the age of twenty-eight, seven days after the birth of her second daughter, never again getting to lay eyes on Alabama. However, her family did bring her home; in 1906 she was reinterred in Thorn Hill's family cemetery. Katherine had a long history with the name Harry Innes Thornton: her brother, husband, uncle and nephew all shared the name.

Colonel Thornton and Anne loved to entertain in their new home with a genuine hospitality ingrained for generations. Guests were often delighted by the treasures used inside Thorn Hill: antique furnishing shipped from Fall Hill and a flowered china pattern that once belonged to Queen Charlotte of England, as well as five notable pieces belonging to General George Washington: a handsome tankard, a spy glass, a candlestick holder and a cup and saucer. Thornton's family had particular favor with Washington. Thornton was a direct descendant of Washington's aunt and godmother, Mildred Washington Thornton. By all accounts, she and Washington were very close, and Washington enjoyed sending her gifts.

Thornton prospered at his new home. By 1850, he had 150 slaves and his estate was valued at $320,000. He and Anne had nine children before

Thorn Hill

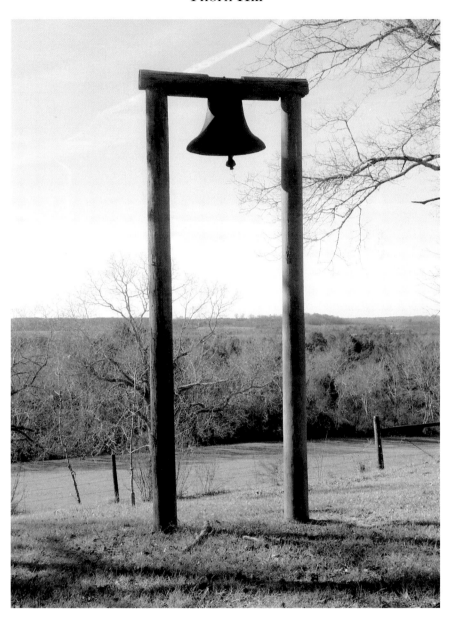

An original Thorn Hill slave bell, January 2009.

she died in 1864 at fifty-two years old. He then married Sarah Williams Gould Gowdy of the Hill of Howth in Boligee, a woman who came from a long line of trendsetting females who were well spoken and accomplished in directing their own destinies. Her parents were William Proctor and Eliza Chotard Gould. Eliza served as a French interpreter for General Jackson. The two became close friends, and he presented her with a portrait of himself that now hangs in a museum in Mobile as an expression of his friendship and gratitude for her help. Eliza's mother (and the grandmother of Sarah Williams Gould Gowdy Thornton), Sara F. Williams Chotard, at age fifty, convinced General Jackson to sign over to her land in Bibb County. She later settled a new community there that would organize into modern-day Centreville. Chotard spent the better part of three decades fighting for this land, which she believed was rightly hers through inheritance from her first husband, Revolutionary War veteran Henry Willis. Colonel Thornton and Sarah Williams Gould Gowdy did not have any children together, and Thornton died in 1877 at seventy-seven years old.

Thornton's descendants are strong both in number and accomplishment. Thornton now has more than eight hundred descendants, who stretch across not only this nation but also the globe. There are direct ties to other famous Black Belt plantations, such as the Hill of Howth and Myrtle Hall (originally Boligee Hill). So far, the descendants of Colonel Thornton have organized four reunions, in 1990, 1995, 2000 and 2005, at Thorn Hill. The result is an incredibly large and accurate family tree, complete with pictorial and written family histories. Colonel Thornton's second daughter with Anne—Delia Francis Thornton Gould—married John McKee Gould of the Hill of Howth in Boligee. Gould's great-granddaughter, Julia Bouchelle Blood, submitted this story for the program for the 1995 reunion:

Right after the Civil War, on the first day that the former slaves were voting, the men had gotten together in town and decided they could control the situation better if they got certain people drunk. So, great grandfather John McKee Gould sent a whiskey jug back home to the Hill of Howth to get it filled. Along with the jug, the black man delivering it also handed great grandmother Delia Francis Thornton Gould a note. She had been extremely nervous all day about what might happen in town. When she saw the note which had been quickly scrawled, she read: "Fire and Retire." She was terrified! She didn't fire, but she did retire to the inside of the house. That night her husband explained the note read, "Fill and Return."

Thorn Hill

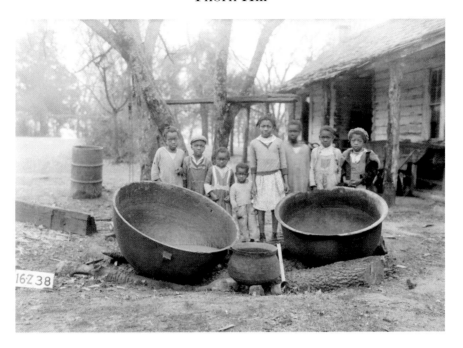

Thorn Hill residents and wash place, 1934. *Courtesy Library of Congress, Prints & Photographs Division, HABS, Alex Bush. ALA, 32-Watso-1-34.*

Julia Blood also related this story, often told to her by her father:

> *When my father was a little boy, he was sitting on the carriage beside his grandfather John McKee Gould. As they approached a gate on the plantation, a little black boy walking along the road ran ahead and opened the gate, bowing low to Captain Gould, who, in turn, tipped his hat to the little boy. As they drove on my father asked, "Grandfather why did you tip your hat to the little colored boy?" His grandfather Gould answered, "Well, now, I couldn't let him be more polite than I."*

It was not Delia who inherited Thorn Hill but rather the youngest son of Colonel Thornton and his second wife Anne, Harry Innes Thornton, who was married to Sallie Blocker. When this second generation of Thorn Hill Thorntons died, their second son, named after the home's builder, James Innes Thornton, inherited Thorn Hill. He was married twice, to Betty Woolf of Demopolis and then to Helen Williamson Allison of Tuscaloosa.

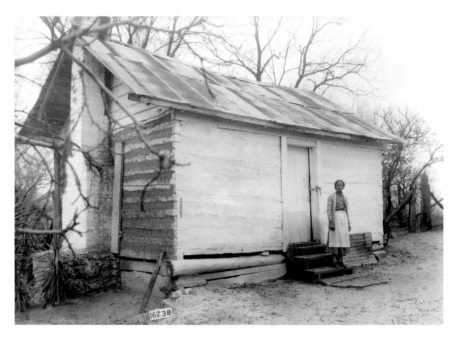

Thorn Hill housekeeper, 1934. *Courtesy Library of Congress, Prints & Photographs Division, HABSA, Alex Bush. ALA, 32-Watso-1-26.*

Under James Innes Thornton's tenure, Thorn Hill was expanded. The family added a basement in the 1920s. At this time, the area near Forkland where the plantation sat was called Watsonia. The Thorntons ran Watsonia's post office and general store out of Thorn Hill's new basement. Ironically, in the 1850s, Greene County was the most populated county in Alabama; now, just shy of 160 years later, it is one of the least populated. When James Thornton's second wife Helen died, Thorn Hill was put up for sale via auction. Descendants of Harry Innes Thornton's sister—Delia Francis Thornton Gould—decided to step in and purchase the home. Brockway Jackson, husband of James Innes Thornton's great-great-granddaughter, Anne Minor Jackson, purchased the plantation in 1964. It was Jackson's daughter and son-in-law, Watson and Anne Jones, who were the next owners. Today it is owned by their son Brock Jones and his wife Anne. Jones splits his time between tending to the plantation and his career as a wealth manager in Tuscaloosa.

"It is really so special," says Jones, the great-great-great-great-grandson of Colonel James Innes Thornton. Since taking ownership, Jones has organized

Thorn Hill

the four family reunions, as well as restored much of Thorn Hill. "Thankfully it has never been in as bad of shape as many others [antebellum homes] because it was never abandoned," says Jones. He built an addition on to the back of the house in 1994 that offers the conveniences of modern life so as not to disturb the integrity of the original structure. Today the basement serves as a playroom, filled with modern toys like pool and ping pong tables, as well as treasures from the past, such as a series of maps dating back to the 1800s. One drawn in 1839 shows the location of Thornton Hill. Although there have been changes, there is still a plethora of preserved history living on at Thorn Hill, carefully kept by Jones and his two sons, Daniel and Thornton, and daughter, Susannah. As they fish Thorn Hill's lakes, hunt its land and tend the 1,803 acres of cattle, corn and soybeans, there is a spirit of nostalgia that accompanies them. Their ancestors, including Colonel James Innes Thornton and Anne Amelia Smith, are no doubt watching over them and the home that they loved from the family graveyard sitting on a hill to the east of the family mansion.

Thorn Hill was added to the National Register of Historic Places on May 10, 1984.

Chapter 3

MYRTLE HALL

Boligee, Greene County, 1839

Myrtle Hall, originally known as Boligee Hill, is one of the few antebellum homes resuscitated just before it was too late, unlike many of its once glamorous, pillared counterparts that have been lost to the forces of time and nature. The rescuers are Chip and Teresa Beeker of Eutaw. Teresa is a descendant of Innes Blocker Thornton Brown, the seventh child of Colonel James Innes Thornton and his wife Anne Amelia Smith of Thorn Hill Plantation. This is just one of several connections between the families of these two plantations.

In 1995, Chip Beeker was in the hospital having his appendix removed when his mother noticed that the old Myrtle Hall Plantation was for sale. It was a place that the Beekers knew well. Teresa had taken trips there as a young Girl Scout, and Chip had gazed up at the declining mansion many days from his catfish ponds, which sit just across the road from the hill that Myrtle Hall crowns. Upon hearing his mother's news, Chip Beeker decided that he must have the old home, so he dispatched his youngest son, Chris, to secure the purchase, as he could not yet leave the hospital. Teresa Beeker was not thrilled when she first found out that her husband had decided to buy the 6,607-square-foot home off Highway 11. The Beekers already owned an antebellum home in Eutaw, and Teresa knew the cost required to keep one up, both in hours and dollars.

When the Beekers purchased the mansion four years ago, Myrtle Hall was literally falling in on itself. The home had no front steps and only a partial roof, as well as extensive water damage inside. Physical damage from vandals and destructive children were painfully evident. "We had to convince the

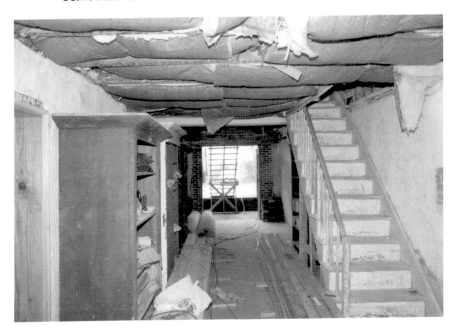

Myrtle Hall interior, circa 1995, pre-renovation. *Courtesy Teresa Beeker.*

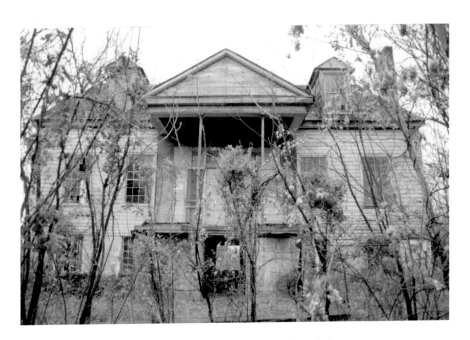

Myrtle Hall exterior, circa 1995, pre-renovation. *Courtesy Teresa Beeker.*

Myrtle Hall

owls, mice and creatures that we were indeed the new owners," remembers Teresa Beeker. Before repairs could even begin, the vacant home of fifty years had to be unearthed from a thriving garden of vines. "It was sad. It needed someone," says Beeker. "We rescued it. My husband enjoys old things and couldn't stand to let the house fall in."

The Beekers spent their entire first year of ownership just redoing the roof. Several people warned the Beekers that Myrtle Hall could not be revived and that the foundation was no longer viable, but the Beekers believed otherwise and set out to prove that Myrtle Hall's antebellum construction could rise to the occasion. "I love it. It just takes your breath away, how they were able to do all this without the materials and tools we have today. Now things fall apart so quickly, yet after all this time, here this still is," says Beeker, sitting victoriously in her refurbished rescue project. The Beekers saved not only an architectural treasure but also a telling page in Alabama's antebellum history.

Dr. David Means of Newberry, South Carolina, was the home's builder. He moved to Greene County in the early 1830s, first living out of tents and then a one-room log cabin as he worked to clear lands and plant his fields. His daughter, Mrs. Eliza Gould Means Picton, captured her family's memories of those years in a work called *Reminiscences*. She writes how kind neighbors sustained her father through those early, lean times, offering friendship and food such as milk and vegetables. She recalls the "vegetable man," Mr. Gould of Massachusetts, who made the two-and-a-half-mile trip from his plantation every other day to deliver fresh goods to Means. Gould's wife was a Frenchwoman named Eliza Chotard Gould, who served as an interpreter for General Andrew Jackson. One is left to think that Means may have named his little Eliza Gould in honor of the benefactor couple who helped him adjust to life in his new home.

In 1832, Means decided to build a proper home for his family, reminiscent of the raised cottage style popular in his birthplace, the Lowcountry of South Carolina. It took seven years, until 1839, to finish Boligee Hill, using mostly native wood from the plantation's grounds. In the meantime, the family lived in the log cabin. In *Reminiscences*, Eliza Gould Means Pictons writes about some of her earliest childhood memories in that cabin—like fending off aggressive wood rats that would carry away a sugar teat or even a whole egg without breaking it. A sugar teat was a treat given to babies, a spot of sugar wrapped and tied up in a small square of cloth. Eliza details how the wood rats would stalk her brother's teats and how he would fight back for his sweet prize, receiving the battle wounds to prove it: deep scratches from the rats'

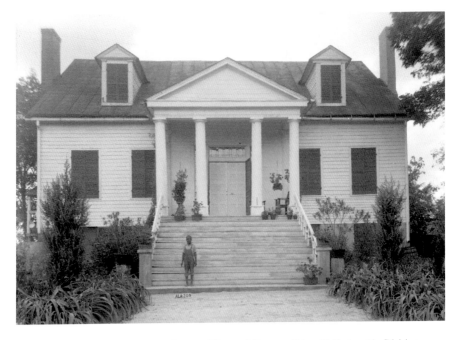

Myrtle Hall front exterior, 1936. *Courtesy Library of Congress, Prints & Photographs Division, HABS, Alex Bush. ALA, 32-Euta-V-1-1.*

claws. She also recalls how Indians would walk up to the log cabin with deer carcasses draped over their necks, trying to sell them to her parents.

Eliza also writes about the day in 1840 when the family moved into their new house, Boligee Hill. She was four years old. The high-basement, raised cottage-style home was certainly an upgrade from the one-bedroom log cabin. The eight-inch keys made an especially powerful impression on the little girl, as did the spinning jenny (a multispool spinning wheel) and flying shuttle (the precursor to the spinning jenny) often used to make clothes for the slaves. Like many of the area's wealthy plantation owners, her parents made steamboat trips to Mobile to purchase luxury items, such as professional cloth, heavy groceries and plants for garden. The name "boligee" means splashing water. Means likely named his plantation Boligee Hill because of all the swamps and running water dotting his property, including Boligee Swamp. Once the target of laughter and criticism from men who thought that the land was useless, Means put both his brain and back to work, designing and building a masterful system of ditches that created the ideal irrigation balance. Boligee Hill became one of the most successful plantations in the area.

Eliza's memoir also contains detailed information about the elaborate first wedding of Sarah Gould, daughter of the couple who fed her father in the early years, William and Eliza Gould. The two families had remained fast friends, and the Meanses were a helpful part of Sarah's wedding to Samuel Gowdy in 1851. Thirteen-year-old Eliza Gould Means and her mother helped prepare for the celebration, including the laborious creation of cakes. There was no powdered sugar back then, so lumps of sugar had to be broken, rolled and sifted through double veiling. Then the cakes were baked in a Dutch oven. Years later, then a widow, Sarah Gould Gowdy would marry Colonel James Innes Thornton of Thorn Hill Plantation.

Another book, *A Goodly Heritage*, also includes a passage about Eliza Means's wedding five years later in 1856 to Charles Picton of New Orleans. William Gould wrote in his journal that Eliza's wedding was early, short and the driest he had ever witnessed. He says that they were asked to arrive at 8:30 p.m. and were home by 9:30 p.m. The Means family lived at Boligee Hill until the end of the War Between States, when they moved to Grenada, Mississippi.

A man of Irish descent, Charles Hays, then moved into Boligee Hill. Hays was raised a Democrat on the Hays Mount Plantation, which used slave labor. He was educated at Green Springs School under Henry Tutwiler and then at the University of Georgia and later at the University of Virginia at Charlottesville. Hays served as a delegate to the Democratic National Convention at Baltimore in 1860 and later became a major in the Confederate army. In 1863, Hays married a gracious woman from Tuscaloosa by the name of Cornelia Minerva Ormond. After the war ended, Hays, then thirty years old, purchased Boligee Hill for his family.

As the Reconstruction era began, Hays switched political affiliations and became a Republican, which also earned him the label of a scalawag in the opinion of many locals. Hays rose through the political ranks, first as a state senator, then as a member of Congress from 1869 to 1877. He found himself ever the controversial figure. At one Republican rally in particular, Hays stood to thank the speakers and adjourn the meeting, but one white man got angry and spoke out—the blacks drew knives, the whites drew guns and several people died. Meanwhile Cornelia Hays was at Boligee Hill, trying to make the house her own, a process one could say became complete in 1869 when she planted such a fabulous garden of sweet myrtles and magnolias that the property took on its current name of Myrtle Hall. Still standing today in the front yard is a stately magnolia believed to have been planted

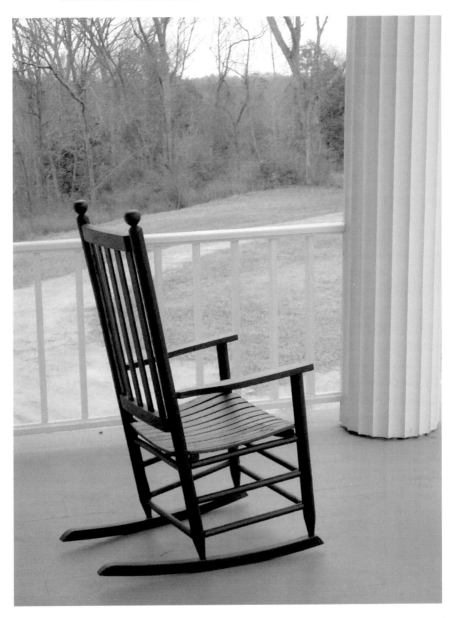

Myrtle Hall porch, January 2009.

Myrtle Hall

by Mrs. Hays's hand in the late 1860s. Just ten years later, two years after retiring from Congress, Charles Hays died of kidney disease at Myrtle Hall at the age of forty-five.

In *A Goodly Heritage*, Roberta Hays Lownder, Hays's granddaughter (daughter of the Hayses' youngest son Charles and his wife Anna McQueen), grants us a fabulous glimpse back into a way of life so quickly and completely lost when she writes about a day at Myrtle Hall. She recalls the great number of servants, how everyone in the home had a personal lamp only they used because although her father Charles wanted to wire Myrtle Hall for electricity, his sister balked, afraid the house would catch fire. Lownder says that the servants arrived at six o'clock every morning and served each person coffee in his or her bedroom. Then the men of the house rode out to check the plantation grounds, and the women began unlocking the rooms of the home, handing out supplies for the day. Breakfast was served at eight o'clock once those chores were complete. Lownder recalls it being a hearty meal, including breakfast meats, bread like waffles or hotcakes and eggs. Next, other chores were tended to, such as going to Boligee for the mail, ice or other needed supplies—a task that fell to the oldest son, Ormond Hays. High noon usually saw another coffee break, and then at two o' clock the servants laid out a generous dinner that was especially elaborate if spend-the-day guests had arrived. Afterward, the family napped until 4:00 p.m., when it was time for carriage rides or a game of bridge or visiting. The family servants went home after the 2:00 p.m. meal, so supper generally consisted of light leftovers from the earlier meal. As the day's light faded, the family visited on the porch, watching the darkness creep up the hill. When it reached them, it was time for bed.

One of Lownder's fondest memories of Myrtle Hall were the gardens that her grandmother Cornelia Hays planted so meticulously. They weren't just reserved for beautiful flowering trees, but also included an orchard of great diversity: peaches, pears and apples. Figs, grapes, cantaloupe, strawberries, watermelons and berry beds also flourished. Myrtle Hall became famous for its blackberry wine. Lownder also recalls how, as children, they were sent to collect wild plums and blackberries. Upon return, their mistress would buy the fruit from them.

Ironically, Teresa Beeker offers a modern update to that theme: her grandchildren love coming to parties at the big house, where they are allowed to pull wagons loaded with drinks. Guests "purchase" a refreshment. At a recent birthday party for Chip, one Beeker grandchild got especially

resourceful and loaded his wagon with beer instead of the usual suspects. He brought in more than six dollars, a real catch for the day.

Lownder also mentions a servant named Nan in *A Goodly Heritage* who is credited with running the home and the important jobs of polishing the silver, waxing furniture and shining mirrors. Lownder took special care to note Nan's immense love of flowers and how Myrtle Hall's front yard was always a garden of blooms to behold.

Despite anyone's reservations about Charles Hays's loyalties, life was grand and warm at Myrtle Hall, and Cornelia Ormond Hays was beloved by all—as evidenced by a *Tuscaloosa Times-Gazette* article republished in *A Goodly Heritage* concerning her death:

> *Perhaps no country place in Alabama is remembered by so many people with such delight, whether it was the hospitality of the owner or the beauty of the place, or both combined which possessed such a charm; certainly it was that the visitor arrived with joy and left with regret.*

After years of rotating owners and abandonment, the Beekers have once again refurbished Myrtle Hall into a charming, welcoming home. The hallway is decorated with scenes from the Civil War, especially the generals, a beloved touch of Chip Beeker's. The pictures include a family favorite of Nathan Bedford Forrest—a planter and soldier whom many folks in Greene County credit with saving homes like Myrtle Hall from the Union troops. Northern generals like Sherman burned much of the South, including the University of Alabama, which sits approximately forty miles away from Myrtle Hall. Forrest is said to have worshipped at the Presbyterian Church in Eutaw—the same one that the Beekers attend now. The church was originally known as Mesopotamia Presbyterian Church in 1824. The congregation had nine white members and two black members. Myrtle Hall is now uniquely personal to the Beeker family.

Teresa Beeker asked each of her three children to decorate a bedroom. Much of the house is filled with antiques from both sides of the family and other new treasures that make for wonderful stories, such as the locks. Vandals had stolen the original locks, crafted by the locksmith for the king of England, which accompanied the eight-inch keys that impressed little Eliza Gould Means Pictons so much. However, Teresa Beeker found exquisite replacements on the internet. She was also able to refurbish a few antiques found in Myrtle Hall's basement, such as the fine American sideboard believed

Myrtle Hall

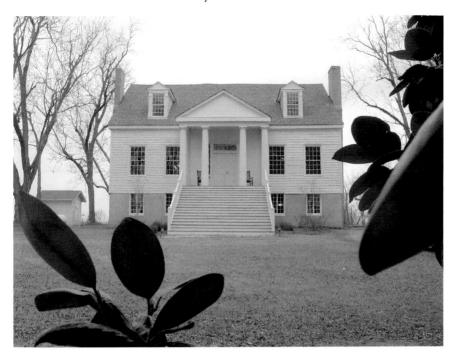

Myrtle Hall exterior, January 2009.

to have been carved by Anthony Quevelle of Philadelphia that now sits in the dining room on the original eight-inch heart pine floors. The home has held on tightly to a few mysteries, such as whether the large brick basement was ever used as a stagecoach stop (local legend says an old stagecoach was once found in Myrtle Hall's bushes), and how the name "Chris—1853" came to be etched onto one of the windows. "It was probably some child who was told he had to clean the windows. He was probably thinking, 'I'll show you,'" smiles Beeker.

The Beekers' favorite spot in the home is Myrtle Hall's back porch. The columns here aren't quite right, despite the Beekers' struggle to rebuild everything to period authenticity. The couple found the perfect set in New Orleans just before Hurricane Katrina hit. The business didn't survive the storm, and for months the Beekers didn't know if or when their custom-ordered columns would arrive. One day, the columns did finally make their way out of a storage room to Myrtle Hall, but they were entirely too small to be considered true to period. However, since the business had closed, the Beekers had no way of returning the columns, so up they went on

Teresa Beeker, current owner of Myrtle Hall.

the back porch. Now, the Katrina columns sit framing the catfish ponds spread out for miles below the home like little shimmering mirrors. As the coyotes offer a serenade at sunset, the Beekers' million-dollar view looks just perfect.

Myrtle Hall was added to the National Register of Historic Places on February 19, 1982.

Chapter 4

MAGNOLIA GROVE

Greensboro, Hale County, 1835

M any men of great authority have passed through the doors of
Magnolia Grove—men who influenced the direction and success of
both the state of Alabama and the United States of America.

The first is Magnolia Grove's builder, Colonel Isaac Croom, a man born
in 1794 in Lenoir County, North Carolina. Croom graduated from the
University of North Carolina in 1815, studied law and became a member
of the state legislature. He never served in the military but, like many fine
gentlemen back then, was given the honorary title of colonel as a gesture of
respect and honor. In 1837, Croom and his wife, Sarah Pearson Croom, made
the move to Alabama, where three of his first cousins were already living.
The Crooms owned plantation lands in south Hale County, North Marengo
County and southwest of what is now Magnolia Grove. This elegant Greek
Revival mansion was built as a town home on a twenty-acre plot of land, not
as a plantation home. The home was designed using a classic four-over-four
design. A dining room, parlor, study and living room were located on the
ground floor; four bedrooms were located upstairs. The home boasts high
ceilings, wide halls and a distinctively handsome winding staircase.

A wide porch sits on the rear of the home, fronted by iron flutes from
England and a deep portico on the front, graced by six massive Doric
columns. The home's name comes from its location, nestled in what was
then a fifteen-acre grove of magnolias. Among the guests who came to visit
was Sarah Pearson Croom's brother, North Carolina chief justice Richmond
Pearson, and his son of the same name, who served as ambassador to Italy
and minister to Greece and Persia.

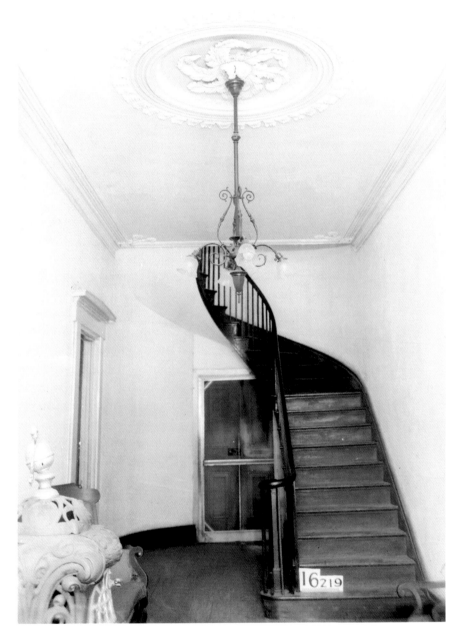

Magnolia Grove staircase, 1934. *Courtsey Library of Congress, Prints & Photographs Division, HABS Alex Bush. ALA, 33-Grebo-1-6.*

Magnolia Grove

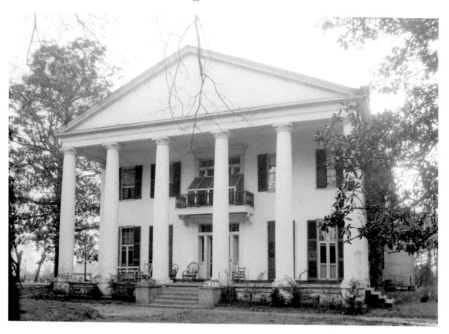

Magnolia Grove exterior, 1934. *Courtesy Library of Congress, Prints & Photographs Division, HABS, W. N. Manning, ALA, 33-Grebo-1-1.*

The Crooms prospered in their new state, amassing a fortune in cotton, land and slaves. Devout Episcopalians, they donated money to begin the University of the South at Sewanee. The recorded amounts differ: either $25,000 or $100,000 was donated. Isaac Croom is officially one of its contributing founders. Back in Alabama, he was elected to the legislature in 1844, representing what was then a part of Greene County. (Greensboro became part of Hale County upon the county's creation in 1867.) Croom also served as the first president of the State Agricultural Society in 1856 and was a key player in introducing the concept of state fairs. He died of pneumonia on February 8, 1863, without leaving a will or any heirs. Sarah Croom buried him in Greensboro Cemetery. She lived on at Magnolia Grove until her death in 1878, when she was buried with her husband.

After Sarah Pearson Croom's death, her niece (daughter of her brother, North Carolina chief justice Richmond Pearson), Sarah Croom Pearson Hobson, bought the home. Many believe that she may have spent a good deal of time at Magnolia Grove growing up. Sarah Croom Pearson Hobson was married to James Marcellus Hobson, another North Carolinian, who

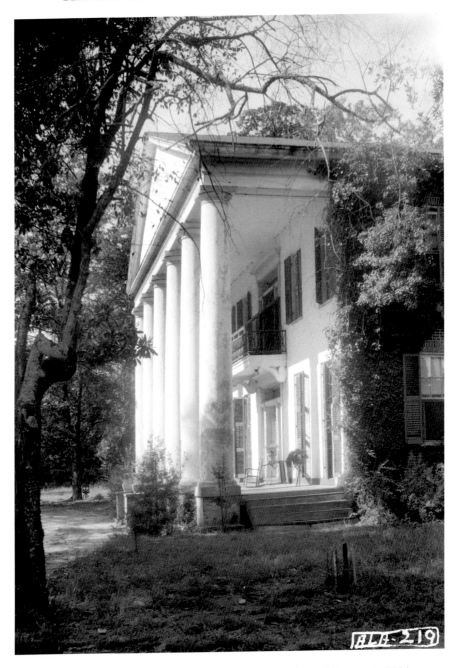

Magnolia Grove side view, 1936. *Courtesy Library of Congress, Prints & Photographs Division, HABS, Alex Bush. ALA, 33-Grebo-1-2.*

fought in the War Between the States and then settled with his wife in Greensboro. During Reconstruction, Hobson was appointed probate judge of Hale County. He held that position for two decades, later receiving appointments by Presidents William McKinley and Theodore Roosevelt to become postmaster general of Greensboro.

The Hobsons had seven children, all of keen mind and ambitious nature, possibly thanks to the strict tutelage of governesses: Samuel, who lived in Haleyville; Joseph, a professor of the classics; James, a West Point graduate who became a professor at his alma mater; Sarah Anne, author of *In Old Alabama*; and Margaret and Florence, who were poetesses. And then there's Richmond Pearson Hobson, the couple's second son. Family legend says that an old family servant named Uncle Ben remembers his "Rich" thrashing a fellow childhood playmate for needlessly destroying one of the boats that the boys were sailing on a pond. At fourteen years old, Richmond Hobson graduated from Southern University in Greensboro and was accepted into the U.S. Naval Academy. In 1889, at eighteen years old, he graduated at the top of his class, number one out of thirty-five, an academic feat both for someone of his age and ancestry. Hobson was the first southerner to attain such academic success at the Naval Academy. Since at that time the academy did not offer graduate programs, Hobson's brilliant mind tackled further study in Paris at *École Nationale Supérieure des Mines* and the *École d'Application du Genie Maritime*. The young Hobson once again excelled, becoming the first non-Frenchman to win the schools' highest scholastic honors. Legend says that, as a student, Hobson predicted an attack by the Japanese on a place such as Pearl Harbor.

In the mid-1890s, Hobson returned to the United States, teaching a course in design and construction at Annapolis while also mapping out a graduate studies program. Then the United States and Spain went to war in 1898. Bearing the titles of U.S. assistant naval constructor and lieutenant, Richmond Pearson Hobson deployed with his fellow officers to Cuba. Rear Admiral William T. Sampson came up with a plan to bottle the Spanish up inside Santiago Harbor: sink one of the U.S. Navy's latest purchases, the *Merrimac*, at the harbor's entrance so the enemy couldn't come in or out. The admiral needed eight volunteers for a mission that seemed to guarantee death. Lieutenant Hobson volunteered and was chosen to lead the effort. He and his men slipped past the guns of Morro Castle, mine beds and broadside batteries of the narrow channel. The eight men stripped the *Merrimac* and were in the process of positioning it and placing the necessary torpedoes to

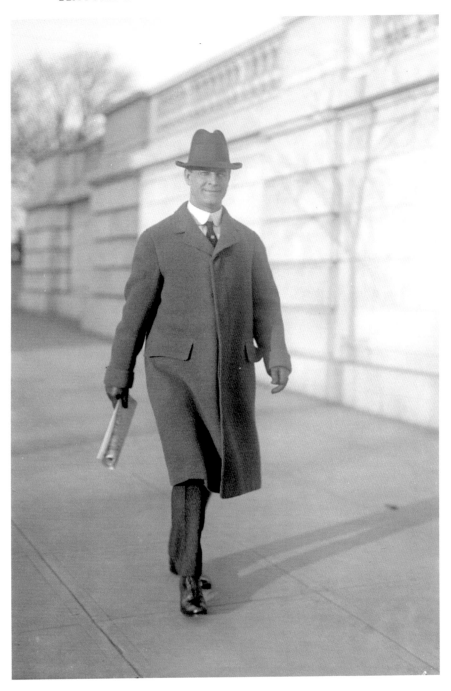

U.S. Representative Richmond Pearson Hobson, 1914. *Courtesy Library of Congress, Harris and Ewing Collection, LC-H261-4802.*

blow it up, when the enemy discovered them and opened fire. The *Merrimac*'s steering gear was disabled, and although it did sink, it was only blocking a portion of the harbor's entrance.

Hobson and his men, clinging to rafts, were picked up by the Spaniards and became prisoners of war. Spanish admiral Cervera so admired the daring feat that he sent Hobson's superior a letter commending the men's bravery and heroism. A month later, Hobson and his crew were turned back over to American forces as part of a prisoner exchange.

Hobson found himself an overnight sensation, a war hero. He began working the lecture circuit and after a time earned two nicknames, "Most Kissed Man in America" and "Hero of the Merry Smack." As Hobson was greeting guests after his public appearances, it quickly became habit that the young ladies all received kisses on the cheek and vice versa.

Hobson then served in the Philippines, the Far East and the Caribbean. He resigned his commission in 1903, his eyes weary from restoration work. In 1905, Hobson married Grizelda Houston Hull of New York. In 1906, he became a U.S. congressman, representing Alabama's Sixth District.

Mrs. Richmond Pearson Hobson and son, Richmond Pearson Hobson Jr., circa 1909. *Courtesy Library of Congress, National Photo Company Collection, npc2007019075.*

Richmond Pearson Hobson, 1898. *Courtesy Library of Congress, Prints & Photographs Division. Reproduction LC-USZ62-54418.*

Magnolia Grove

After serving two terms, Hobson settled into the task of writing books, authoring *Buck Jones at Annapolis*, *The Sinking of the Merrimac*, *Why America Should Hold Naval Supremacy* and *Alcohol, the Great Destroyer*. This last title was the other passion in Hobson's life: fighting alcohol and drug abuse. In 1933, President Franklin D. Roosevelt presented Hobson and his *Merrimac* crew with the nation's highest military accolade, the Congressional Medal of Honor. A year later, in 1934, at the rank of rear admiral, Hobson officially retired from the U.S. Navy.

Three years later, at the age of sixty-seven, the hero of the Spanish-American War passed on in New York City, where he had been living with his wife. He is buried at Arlington National Cemetery.

In 1943, his sister, Margaret Hobson, deeded Magnolia Grove to the State of Alabama, with the express purpose that it be maintained as a memorial to her brother. In recognition and appreciation of Rear Admiral Hobson's many contributions, the Alabama legislature appropriated $7,000 for the restoration of Magnolia Grove that same year. On May 1, 1947, the home became an official state shrine. Miss Margaret and two of her siblings lived on at the home yet were always pleased to open its doors to visitors and laud their brother's achievements.

In 1980, the Alabama Historical Commission took ownership of the house. Today visitors can see not only an impressive collection of family antiques and portraits but also many of the treasures that Hobson collected during his exotic missions and travels. There are also multiple awards and trophies belonging to the family, including a British Military Medal awarded to Hobson's son, Master Sergeant R.H. Hobson. British general H.R. Alexander gave it to the young man for daring exploits during the North African Campaign of World War II. His Majesty King George VI of England approved it on November 24, 1944. However, perhaps the most special piece of all is a simple nameplate sitting by the fireplace, weathered and worn from its days at sea and in a Spanish prisoner of war camp after a young hero stripped it off a ship in a hurried rush. It simply reads "Merrimac."

Magnolia Grove was added to the National Register of Historic Places in April 1973.

Chapter 5

WALDWIC

Gallion, Hale/Marengo County Line, 1840

Waldwic Plantation in Gallion has long been a center of social graces for an area known as the Canebrake—an old lakebed in the watershed of the Tombigbee and Black Warrior Rivers, measuring about 650 square miles, which is in present-day Marengo and Hale Counties. The Canebrake's borders feature Greensboro to the north, Dayton to the south, Uniontown to the east and Demopolis to the west. Waldwic was originally located in Marengo County, but when Hale County was created in 1867, the county line was drawn through the plantation property, so now the Waldwic estate spans the Hale/Marengo county line.

The architectural style of Waldwic Plantation is as magnificent as the stories of the families who lived there and their lavish celebrations. Breaking tradition from its white-pillared contemporaries, Waldwic sprawls out in Gothic Revival style. Robert Gracey had the original house, a cottage, built beginning in 1839 and completed in 1840. "It really started out as just two rooms with a dogtrot running down the middle. The wings were added on later," explains William Spencer III, Waldwic's present owner and a descendant of the Gracey family.

When Robert Gracey died, he left Waldwic to his brother, Minor Gracey, who was married to Mourning Smith, a woman who is a story all by herself. Mourning Smith was originally married to a man by the name of Patterson. When he died, she married Minor Gracey, and when Gracey died, she married the attorney general of Virginia, Willis P. Bocock, and transplanted him to Waldwic for a good portion of the year. "We refer to her as Auntie Bocock. She always told the family she married once for love, once for money

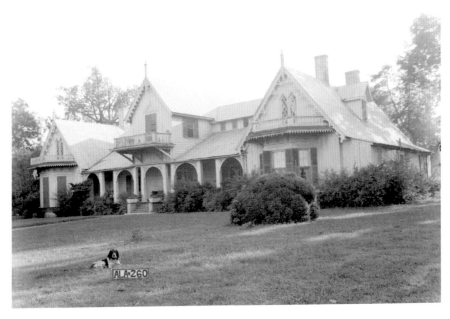

Waldwic exterior, 1935. *Courtesy Library of Congress, Prints & Photographs Division, HABS, Alex Bush. ALA, 33-Gali-1-1.*

and once for fame, but she never told anyone which husband was which," recalls Spencer III. Mourning Smith Patterson Gracey expanded Waldwic out to its current state in 1852. It's one of the few remaining examples of residential Gothic architecture in Alabama.

According to *Chronicles of the Canebrake 1817–1860*, a work written by John Witherspoon Dubose and published by the Alabama Department of Archives and History in 1947, Minor Gracey was a distinguished, handsome man, who enjoyed building Waldwic into a social centerpiece, both through its unique beauty and its meticulous upkeep. Mourning Gracey was a tremendous help, as she was extremely involved in areas that most other women at that time did not tend to: she wanted her horse saddled and ready every morning after breakfast so she could inspect the fields, gardens and hills. She also made sure to ship all of the plantation's extra butter to Mobile so it could be sold, which according to *Chronicles of the Canebrake*, was an unusual practice.

The Graceys were immortalized by the famous American painter William Frye, who spent some time at Waldwic before the Civil War. In 1851, Frye painted what is now known as *Minor Winn Gracey and Mourning*

Waldwic

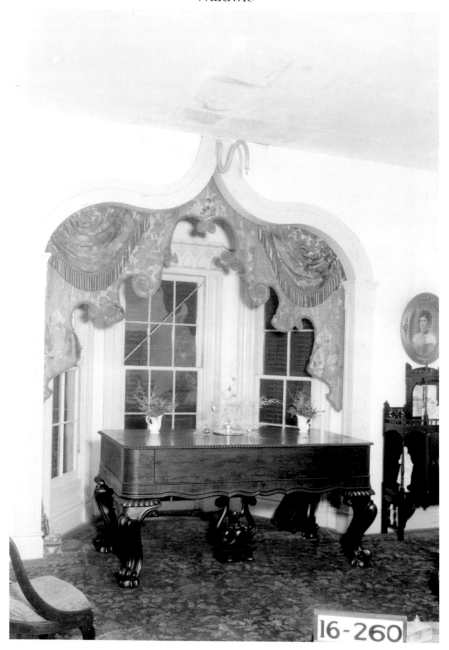

Waldwic parlor windows, 1935. *Courtesy Library of Congress, Prints & Photographs Division, HABS, Alex Bush. ALA, 33-Gali-1-6.*

Smith Gracey, a portrait of the couple in front of a vine-covered balcony with Marengo County's rural landscape rolling behind them. Mrs. Gracey is sitting with a mandolin at her feet. Minor Gracey is standing behind her, his hands resting on the back of her chair. This portrait, along with many others of Minor and Mourning Gracey, hung in Waldwic for decades until it was loaned to the Smithsonian's collection at the American Art Museum for a number of years.

Minor Gracey died of yellow fever after being bitten by an infected mosquito on a trip to Demopolis in 1853. No one yet knew that mosquitoes were the cause of the great epidemic. Historians now believe that the infected mosquitoes arrived in Demopolis via steamboat from Mobile.

Mourning Gracey then met her final husband, Willis P. Bocock, on a trip to the White Sulphur Springs of Virginia. "It was really an amazing trip for Auntie Bocock back then, because you know it was not easy to get back and forth in those days," says Spencer III. The couple married in 1856 at Waldwic in a celebration more opulent than most had seen, from the fine food to the impressive dinner silver service. These festivities set the tone for an even more socially grand time at Waldwic. Bocock embraced his new community and often entertained extravagantly. The Bococks began hosting a weekly chess club that often had more to do with fun than chess. *Chronicles of the Canebrake* describes the schedule as chess in the afternoon, a long walk in the gardens, an elaborate dinner feast and then dancing until ten in the ballroom.

Although married three times, Mourning Smith Patterson Gracey Bocock never bore any children, so she left Waldwic to her niece, Bertha Gracey Steele, Spencer III's grandmother. Spencer III has spent much of his life at Waldwic and seen more than a lifetime of changes. "When I was knee-high to a duck, I can remember the bathroom being in the front yard, washing my face in the commode—which meant a basin and water pitcher at that time. I loved going. It was a wonderful place for a young boy," says Spencer III.

When his family made the journey from Birmingham to Gallion to visit his grandparents, it took the better part of the day because of the poor conditions of the dirt roads. Spencer III remembers the family car getting stuck and his grandfather's mule team arriving to pull them out. Once at Waldwic, Spencer III was often responsible for catching chickens for that night's dinner, wringing their necks and hanging them in the trees. The young boy found time for mischief as well. "I can remember sneaking into the hen house, stealing the eggs, and then hiding them inside the rooster cages. The cooks would get so excited, hollering about how the roosters

Waldwic

William Spencer III, Waldwic's present owner and a descendant of the Gracey family, February 2009.

had laid eggs! I have so many fond memories of that place as a child," says Spencer III with a smile.

Bertha Gracey Steele had three children and decided to leave Waldwic to her oldest son, William Spencer II, because he was the only one with children. William Spencer II, who is William Spencer III's father, earned his law degree from Harvard and had a thriving law practice in Birmingham until the Great Depression.

"He gave up law for a little while because no one was paying lawyers," says Spencer III. Spencer II then decided to capitalize on his farming roots. He moved his family back to Marengo County so he could run Waldwic, then a 6,500-acre plantation that produced corn and cotton and supported a dairy. "Dad said our farm produced more milk than any other place in the state, but I doubt that's true. Just Marengo County had nearly seventy-five dairies at one point. Most stayed in operation until after World War II, when the Wages and Hours Act forced most to close because all of the cows had to be milked twice a day," says Spencer III.

At that point, Spencer III's aunt and uncle had already moved into Waldwic, so his father rented Gaineswood Plantation in Demopolis for his family to live in at a price of twenty-five dollars per month. Spencer III lived there from ages twelve to sixteen and attended Demopolis High School. "No doubt these were terrible years for many, but for me, the Great Depression was the best time of my life. I had a horse in the backyard of Gaineswood, and after school, I'd jump on, and away we'd go for the rest of the day," says Spencer III.

In the late 1930s, Spencer II moved his family back to Birmingham and began practicing law again, while continuing to also successfully run Waldwic. Spencer II was a member of the Birmingham Botanical Society, a board member for Children's Hospital and chairman of the Birmingham Museum Board—a post that he held for twenty years. Spencer II's love of art inspired several fundraising campaigns benefitting the Birmingham Art Museum, which led to the construction of the East Wing in 1967 and the William Spencer Galleries in 1974.

Waldwic slave quarters, 1935. *Courtesy Library of Congress, Prints & Photographs Division, HABS, Alex Bush. ALA, 33-Gali-1-11.*

Waldwic

Spencer II and his wife, Margaret Woodward Evans, evenly divided Waldwic between their three children: daughters Margaret Woodward Spencer and Bertha Underwood Spencer, as well as their son, who after his years at Demopolis High went on to graduate from the University of the South in Sewanee, earn the rank of captain while serving with the U.S. Marine Corps in World War II and become a chemist who played a major role in founding and developing the companies Motion Industries and BioCryst Pharmaceuticals. The three siblings raised catfish at Waldwic for a time but now stick to beef cattle.

When Spencer III took responsibility for the house, he embarked on a major modern remodeling job, including installing modern bathrooms and heat. He also closed up the fireplaces and the upstairs bedrooms. Much of the renowned Gracey art collection is still on display downstairs, including two vases and the mandolin featured in some of the portraits of Minor and Mourning Gracey. William Frye's famous portrait of the couple is now back at Waldwic as well, once again allowing the couple to watch over all the comings and goings at their beloved home.

Waldwic Plantation was added to the National Register of Historic Places in 1994.

GAINESWOOD

Demopolis, Marengo County, 1843–1860

G aineswood Plantation is the product of one man's commitment to beauty, functionality and innovation—a personal playground for the ever-creative mind of Nathan Bryan Whitfield.

The son of General Bryan and Winifred Whitfield, Nathan Bryan Whitfield was born in 1799 in Lenoir County, North Carolina, where, following in his father's illustrious footsteps, he became successful at many of life's endeavors: business, politics (he was a member of the North Carolina legislature) and the military (Whitfield became a general in the North Carolina State Militia at thirty-one years old). Despite his many accolades and successes, Whitfield's spirit craved something else—the challenge and excitement of helping to settle the Black Belt of Alabama. Relatives already living in the Black Belt had written Whitfield, lauding the area's many accolades. In 1833, Whitfield went to visit his uncle Colonel J.R. Bryan and fell so in love with the land that he purchased his first plantation, known as both Chatham House and the Lower Plantation.

In 1834, Whitfield, his wife Elizabeth, their four children and one hundred slaves packed up and made the trek back to what was the region then known as "the Marengo." They settled at the Chatham House, a home that was ten miles southwest of Demopolis and that suited the family just fine for eight years. These were the early, tough years. At one point, Whitfield had to leave Elizabeth, four months pregnant, and their four small children alone in what was then an open-air cabin to return to North Carolina for supplies and furniture. It was also here at Chatham that Whitfield met a neighbor who would become very important in his life, General George S. Gaines,

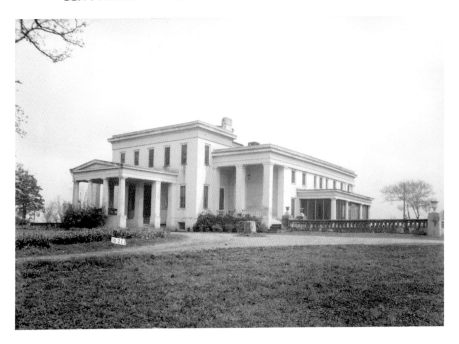

Gaineswood exterior, 1934. *Courtesy Library of Congress, Prints & Photographs Division, HABS, Alex Bush. ALA-46-Demo-1-10.*

a Choctaw Indian factor. (His brother, Captain Edmund Gaines, captured Vice President Andrew Burr, then accused as a traitor.) General Whitfield and General Gaines became close friends with much mutual respect.

In 1842, yellow fever swept the area, claiming many victims, including three of the Whitfield's children: ten-year-old Edith, five-year-old James and three-year-old Sarah. The family, shrouded in grief and worry, accepted the invitation of friend Augustus Foscue to come stay with him in Demopolis for several months and "bring as many servants as would make you feel at home." Gaineswood records also show that Foscue's invitation mentioned their "misfortunes…of the most distressing kind" and that "for no doubt but a change of air and water and sun would all contribute to your health and comfort more than anything else." The Whitfield family agreed and came to visit the Foscue home for several months. That home is still owned by the Foscue family, who leases it out now as a restaurant bearing the family name.

At the same time, the Choctaw Indians had finally been pushed out enough by the white settlers that there was no longer need for Indian Agent Gaines in Alabama, but instead he was needed farther west. Gaines, preparing to move,

Gaineswood

sold his property on the then outskirts of Demopolis to his friend Whitfield, including a log cabin and an oak tree where, legend says, Gaines and Chief Pushmataha signed the treaty removing the Choctaws to the West. General and Mrs. Whitfield, along with their eleven children, moved into the double-pen dogtrot cabin. This cabin was expanded and improved into what is now the glorious Gaineswood mansion, named after Whitfield's dear friend, General Gaines. Inside the home today, the old log cabin built in 1821 is now the gift shop and entry hall. Whitfield originally built Gaineswood around the cabin, intending to keep it intact. After construction was complete, Whitfield became concerned that the cabin's wood might rot and then spread and ruin the rest of the home. He went back and tore the cabin's skeleton out of Gaineswood.

Gaineswood took eighteen years to build, and visitors can see why. Whitfield was the brains behind it, and he also enlisted the help of talented slaves, freedmen and traveling master artisans to make his home perfect. We know of some of them: Willie the blacksmith, Dick the master builder, Sandy the mason and James the carpenter. John Verdin spent almost two years painting the faux grain wood trim throughout the house, and John Gibson is responsible for the art glass transoms. A man named Isaac is believed to have worked on the home's columns. Isaac was General Whitfield's traveling companion, surely a special man to the general since he had both himself and Isaac vaccinated for smallpox in 1825. These people all helped produce a home that has been heralded by many for its unique beauty. In *Ante-Bellum Mansions of Alabama*, Ralph Hammond calls Gaineswood "the glorification of the Greek Revival —the glorified embodiment of the finest as exemplified in the Neo-Classic." Although Whitfield did employ the help of the same pattern books that many of his fellow planters used, he also dedicated himself to learning all he could about Greek architecture. He studied such books as *The Antiquities of Athens* by Stuart and Revett, as well as works by Vitruvius, a Roman architect who wrote *De architectura*, also known as *The Ten Books on Architecture*, what many consider the only surviving major book on architecture from classical antiquity. When designing his home, Whitfield subscribed to Vitruvius's mantra of three necessary characteristics: strong, useful and beautiful.

Not only did Whitfield lay out superb plans for his home, but he also built the machines and shops necessary to create the appropriate materials right in his plantation. Gaineswood played host to carpentry and batter houses, as well as a whirling lathe to cut the cornices and columns powered by an eight-mule team that circled a gear shaft. His attention to the detail of the home's decoration was meticulous: a fresco was painted by a traveling Polish artist

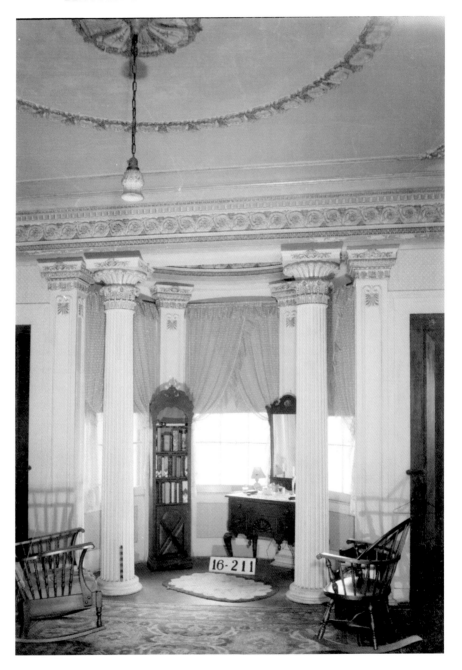

Gaineswood bay window in mistress' bedroom. *Courtesy Library of Congress, Prints & Photographs Division, HABS, Alex Bush. ALA-46-Demo-1-47.*

on the ceiling of the porte cochere, the main entrance to the house on the west; and on the north veranda, not one but two rows of Doric columns, one square-shaped of stone and concrete and the other rounded and fluted and made of wood. Gaineswood's drawing room is a particularly exquisite room, even for Gaineswood. It boasts fluted pilasters, vis-à-vis mirrors that provide thirteen reflections and corner reflections of the room, as well as identical gray marble mantels at either end of the room decorated with wreath rosettes.

Balance, symmetry and space were very important to Whitfield. Visitors must be sure not to miss the view above: the drawing room's ceiling is composed of detailed interlocking beams that create beautiful coffers studded with dainty rosettes. Whitfield's inspiration for the Corinthian order in the room is the Choragic Monument of Lysicrates in Athens. His youngest daughter, Mrs. Nathalie Whitfield Winn, told stories before her death about the grand balls that her parents used to host in this room and how Indians would peep through the windows to watch. This room was also the stage for the Whitfield boys' fencing lessons. When the fencing artists from France arrived, Whitfield ordered his slaves to carefully wrap all the chandeliers and mirrors for protection. Winn also recalled her brother's wedding in the room. The final wall had not yet been built, so the ever-resourceful Whitfield purchased a thirty-foot sheet of canvas and hand painted it with the appropriate cornices, mirrors and columns to match the other walls. Winn says that the job was so perfect that very few guests realized it was merely a drawing. Today the drawing room, and much of the house, plays host to modern-day community activities such as proms, graduations and weddings.

In 1846, Elizabeth Whitfield, often called Betsy, died of an intestinal disorder, weighing just fifty-five pounds at her passing. She was the moral guardian of the home, and a woman who, by all accounts, worshipped her husband. Whitfield was devastated and threw himself even more fully into designing and building Gaineswood. In July 1857, he married a young girl named Bettie who had come to Gaineswood more than a decade ago to help with the children. Likely looking out for the children he had sired with Elizabeth, he insisted Bettie sign a prenuptial agreement giving her just $10,000, or a child's share of the estate, upon his death. He and Betty had one child together, Nathalie Ashe Whitfield, who was sixteen years younger than her closest sibling. Whitfield reportedly doted over the baby, even getting up in the middle of the night and lighting a candle just to look at her. A lithograph of Gaineswood shows General Whitfield and Bettie walking behind a nurse named Ann, who was strolling little Nathalie along the lake that at one time surrounded Gaineswood.

Reproduction of lithograph depicting Gaineswood in early 1860s. *Courtesy Library of Congress, Prints & Photographs Division, HABS, E. W. Russell, 1936. ALA-46-Demo-1-67.*

Back inside the home, Whitfield's commitment to beauty and usefulness shines through again in the dining room and library, where ceiling domes topped with cupolas are stunning visual additions yet practical because they're a grand source of light for both rooms. Whitfield lavishly decorated them with renditions of Ionic columns, acanthus leaves, honeysuckles and flowing scrolls. In *Ante-Bellum Mansions of Alabama*, Hammond writes about Whitfield's devotion to his plans, blueprints that could not be deviated from for any reason:

> *General Whitfield was a stickler when it came to carrying out his plans. His daughter Winn told another story of how he journeyed to Mobile for a lengthy business trip, and upon returning, found that the parlor ceiling had been completed as a flat surface without the dome and cupola. He immediately ordered the ceiling removed to make way for his own design. A plaster artisan by the name of Vincent, from Philadelphia, who had been hired to assist the general in executing the plans, soon found that to deviate from the drawings meant the re-doing of the entire job.*

But Whitfield was open to new ideas. In 1849, his son Bryan Watkins Whitfield, while home on break from the University of North Carolina, suggested that his father add an uncovered observatory to the roof.

Gaineswood

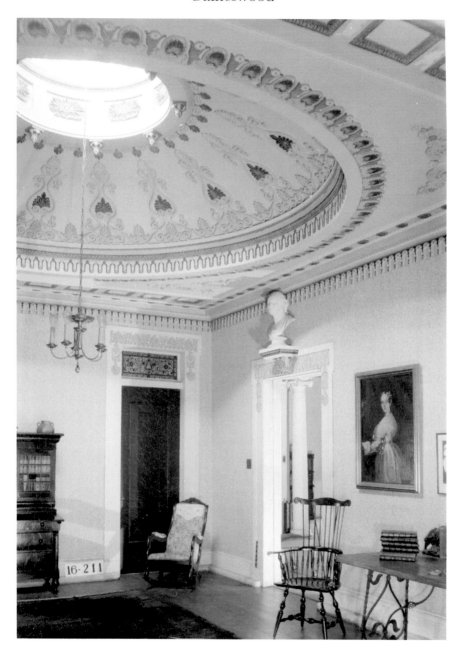

Gaineswood library ceiling, 1934. *Courtesy Library of Congress, Prints & Photographs Division, HABS, Alex Bush. ALA-46-Demo-1-34.*

Whitfield did just that, and "the Ring" became a popular evening spot for the Whitfields, as their children enjoyed performing musicals and such from within it. Whitfield himself played the violin and bagpipes, his daughters the harp and piano. Whitfield also designed for his children's entertainment a flutina that still sits in Gaineswood today. He sent the plans to New York to have the instrument commercially produced. It is the only one of its kind in the world, since the design was never patented or reproduced.

Whitfield is often referred to as the Thomas Jefferson of Alabama. In addition to his talents of engineering, architecture, design and business, he was also an accomplished artist, as evidenced by the canvas wall he painted for his son's wedding and the many family portraits still hanging in Gaineswood today. Whitfield hand painted portraits of his parents and his daughter Edith Winnifred—who died of yellow fever on the Lower Plantation—from memory. He even designed Vitruvian scrolls or waves that decorate the steps of the entryway staircase. Each scroll or wave depicts the sea crashing on a shore, which represents "eternity." Inside each wave's negative space is a cornucopia, which denotes "prosperity." This was Whitfield's wish for Gaineswood and his family—never-ending prosperity.

Whitfield planned to do more to Gaineswood, yet the Civil War interrupted his plans, and he died in 1868 with ideas and projects left undone. Before Whitfield died, he sold Gaineswood to his son, Dr. Bryan Watkins Whitfield. Subsequently, in 1896, Dr. Whitfield sold Gaineswood to his sister, Edith James Dustan. Gaineswood remained in the Whitfield family until 1923, when it passed on to several other owners, a mere shadow of itself. At one point, goats slept in the drawing room and a mulberry tree grew up through the dining room skylight. In 1946, native Alabamian Dr. J.D. McLeod and his wife purchased it, as they were ready to retire in Alabama after years in Ohio. The couple began the process of restoring the valuable mansion. The State of Alabama bought Gaineswood in 1966 and continued that mission, which in some ways still continues today. In 1975, the Alabama Historical Commission opened Gaineswood to visitors as a museum. Today they see it restored, much like it was when the Whitfield children were growing up, a place Nathalie Whitfield Winn remembers fondly: "The whole thing is a symphony—the proportions so perfect, the detail so in tune."

Gaineswood was added to the National Register of Historic Places on January 5, 1972, and designated as a National Historic Landmark in November 1973.

River Bluff House

Camden, Wilcox County, 1847

A lthough smaller in stature than many if its contemporaries in this book, River Bluff House is a charming example of antebellum architecture that has played a large role in Wilcox County's history and has been instrumental in telling the story of the Old South's rise and fall.

Thomas Dunn, a generous real estate owner who gave property to churches and local government in order to create Camden, bought the forty-acre River Bluff House property from the eighth president of the United States, Martin Van Buren. Sometime later, Dunn sold the property to the home's previous namesake, Judge William King Beck (1802–1890), who was the nephew of Vice President William Rufus King, his mother's (Margaret DeVane King Beck) brother.

Beck built what came to be known as the Beck Place, now the River Bluff House. The Greek Revival cottage showcases a recessed porch framed by impressive columns that, some say, suggest that famed architect Alexander Bragg played a role in the design and construction.

This home etched its place in Alabama history as the site at which one of the many touching stories in the War Between the States played out. Many of Wilcox County's young men joined the South's cause and enlisted in the local Confederate unit, the Wilcox True Blues. On February 12, 1861, the unit marched out to war under the command of local doctor and newly named regiment captain I.G.W. Steadman, who later rose to the rank of colonel of the First Alabama Regiment. The women left behind were determined to do more than whisper prayers and shed tears. They set to work trying to create a proper flag for their men to carry into battle. Miss Adele Robins (later

River Bluff House porch, February 2009.

Mrs. Spencer) voluntarily surrendered her blue silk dress for the project, and the women of Wilcox County, along with Samuel Tepper, gathered in the parlor of the River Bluff House to create a symbol that they hoped would bestow on their men luck, inspiration and protection. Within River Bluff House's walls, this team designed and fashioned a beautifully detailed piece of Wilcox County history that has woven an incredible story all its own.

Historical notes from the United Daughters of the Confederacy tell us that the Wilcox True Blues was a unit of young soldiers, ranging in average age from eighteen to twenty-one years old, with a few volunteers as young as fifteen; these young men were generally from the premier families of the area. The First Alabama Infantry initially deployed to the Pensacola area, where the soldiers abandoned most of their cold weather supplies for easier mobility. The soldiers then moved out to the New Madrid area of Missouri, where they were charged with holding a strategic Confederate position called Island Number Ten on the Mississippi River. It sat in a tight double turn of a bend. That location gave whoever had control of the island an excellent position from which to attack boats coming downriver since the captains not

River Bluff House

River Bluff House parlor, where the Wilcox True Blues Flag was sewn, February 2009.

only had to slow their vessels but also come within close range of the island in order to navigate the turns. However, it was imperative that the supply lines for Island Ten remain open, or else the soldiers on it became nothing more than stranded targets when ammunition ran out.

Union troops under the command of Brigadier General John Pope used that angle as their strategy. They came across the land through other fallen Southern towns like Point Pleasant and New Madrid, eventually cutting off the island's critical supply lines and escape routes. Besides the impending military conflict—in which some reports suggest that the South was outnumbered three to one—all sorts of illnesses were racing through Island Number Ten—measles, mumps, whooping cough and more. They descended over the soldiers along with the cold weather and rain. The First Alabama Regiment held on for almost six weeks, late February to early April, during what has become known as the Siege of Island Ten.

As it became apparent that the approximately seven thousand Confederate soldiers were no match for the Yankee Army of the Mississippi and its Western Gunboat Flotilla (six gunboats and eleven mortar rafts),

the men accepted the idea of surrender and the consequence that they would therefore also become prisoners of the North. However, Colonel Steadman decided that he must at least save the True Blues' flag, an item he and his men had fervently guarded and treasured since leaving Wilcox County. The twenty-six-year-old colonel, seriously ill at the time, instructed a soldier from Oak Hill, James Dale, to take the flag and bury it away from Yankee hands. After burying the flag, Dale was captured, imprisoned at Camp Butler in Chicago for seven months and, in declining health, made it back to Wilcox County on furlough from an army hospital just in time to take his last breaths. Colonel Steadman was also captured by the Federals. Just before he was sent to St. Louis, Steadman disclosed the location of the buried flag to his nurse and fellow soldier William Newberry of Oak Hill. Willie, as he was known to friends, dug the flag up from its shallow grave, sealed it in a fruit can and gave it to a lady friend for safekeeping. After surviving all of this, it appeared that the True Blues' flag would have to follow in the footsteps of Company B and ultimately surrender. William Newberry was captured as well after turning over the flag to his friend. He died at Camp Butler in Chicago, and along with him, the most realistic hopes of ever returning the flag to Alabama.

Decades later, a brief glimmer of optimism surfaced when reports came in that a flag similar to the True Blues' had been located in Madison, Wisconsin. Hopes for its return were dashed when the custodian of the Military Museum at Madison wrote that a fire had wiped out most of the museum's treasures in 1904. The quest to bring the Wilcox True Blues' flag home appeared finished until 1917, when the daughter of a private in Company B, Richard McWilliams of the Sterrett-McWilliams House, stumbled on the flag in Lansing, Michigan. It was only then through McWilliams's efforts (see the chapter on the Sterrett-McWilliams Home) that the True Blues' flag finally made the long journey back to its proper home.

Back at the River Bluff House, William Beck and his wife, Eliza Smith of Wilcox County, never had children; instead they adopted a daughter, Ada Beck, formally known as Anne Simms Beck. Family legend says that although Beck and Eliza did not have any biological children, he did sire children (Susan, Josephina and Frank Beck) with one of his slaves named Harriett on another plantation he owned in Shreveport, Louisiana. Some historical data also seems to support this claim. Records in Bossier Parish, Louisiana, do list an appointment by then governor Mouton to one William King Beck in 1843 as the first judge of the parish. Records from 1850 in

River Bluff House

River Bluff House gas lantern, February 2009.

Wilcox County show no mention of William or Eliza Beck. Legal records from a land purchase and subsequent lawsuit alleging breach of agreement place Beck in Wilcox County in 1832 (land patent) and in 1859 (lawsuit). Harriett Beck's descendants say that they are indeed from Beck lineage and not just in name alone (many slaves took on their master's names). After the War Between the States, Beck moved Harriett and her children from Louisiana to the River Bluff House. Harriett's descendants also say that her original surname was Devan and that she was owned by the DeVane family, from which Beck's mother Margaret came in North Carolina.

Ada Beck inherited the home after her parents' deaths—William Beck in 1890 and Eliza Beck in 1895—and she sold the property to Joseph Neely Miller on September 8, 1904. The house was then owned by the Bryant family—starting with J.D. Bryant, who is rumored to have remodeled the roof, then Don Bell and later Mr. and Mrs. Jim Bridges.

Today, another ironic connection to Louisiana is playing out. The River Bluff home is now owned by the Douglas R. Talbot family from New Orleans. Doug Talbot owns the Lucky Dog hot dog business that French

Quarter visitors can't help but notice and often enjoy. The family employs Wilcox County local Frank Chapman to take care of the property. As a young boy, Chapman grew up just down the road from the River Bluff House in the 1950s when Presley Bryant owned it. A seven-year-old Chapman would often pop into the fields of the River Bluff House for a quick romp or chat with Bryant, a man who he remembers as dignified and generous. "He knew I loved horses but was never able to have one. So one day he gave me a McClellan military saddle. I was so proud, just tickled to death. I'd put that saddle on the banister of my house and pretend I was riding away," says Chapman with a smile.

Long retired, Chapman now treasures his role as caretaker of his childhood playground, a telling gem in Wilcox County's storied history.

Chapter 8

STERRETT-MCWILLIAMS HOUSE

Camden, Wilcox County, 1851

T he unique style and commanding beauty of the Sterrett-McWilliams House in Camden has earned it a place in the history books, as has the story of the home's beginnings.

Judge David W. Sterrett moved to Camden while he was still an attorney and quickly became an admired, well-respected resident. Through the years, he bore the titles of legislator, planter and trustee of the Wilcox Female Institute. When Judge Sterrett decided to build a home, he was anxious to make a statement and build something suitable for a probate judge. "When Judge Sterrett was designing his home, he wanted to try and outdo other lawyers in town. He decided to do something as different as he could," says Garland Cook Smith, the home's current owner. The Sterrett-McWilliams House certainly embodied Judge Sterrett's goal of distinguishing him from his colleagues but likely not in the exact manner for which Sterrett had hoped.

The Sterrett-McWilliams House is one of the finest examples in the South of antebellum eclecticism, a term that architectural historian Robert Gamble uses to describe the trend of combining architectural styles to result in hybrid homes, not completely matching any one traditional design:

Like countless American houses of the mid-late 1800s, it cannot be pigeonholed into any neat stylistic category. Clearly, however, it shows the influence of popular architectural pattern books of the period which—themselves—exhibited some pretty creative mixing of details from here and there. Beginning in the last decade before the Civil War, Alabama home builders seem to have taken particular

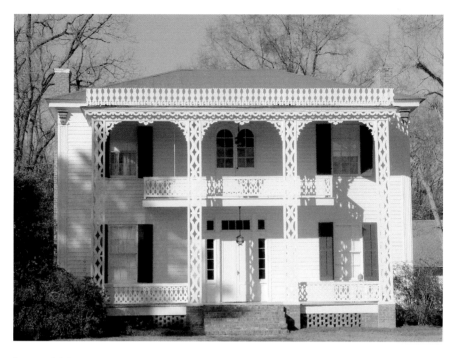

Sterrett-McWilliams Home exterior, February 2009.

delight in mixing various influences and details to come up with their own confections. It's one of the beguiling things about dwellings of this period.

The Sterrett-McWilliams House combines Greek Revival, Italianate, Victorian and a touch of Haitian influence.

The home's architectural pattern was inspired by the work of Samuel Sloan, a Philadelphia carpenter and architect whose pattern books became popular in the Deep South, as well as other parts of the country. Sloan wrote such influential works as *The Model Architect, City and Suburban Architecture, Sloan's Constructive Architecture* and *A Variety of Designs for Rural Buildings*. Architectural pattern books were a popular tool of the times in the first half of the nineteenth century, as the immediate demand for grand home designs fueled by flush times greatly outpaced the supply of available architects. Garland Smith also believes that she sees glimpses of the hand of architect Alexander Bragg around her home. Bragg designed the famed Bragg-Mitchell home in Mobile for his brother, as well as the Wilcox County Courthouse, one of the few antebellum courthouses still in use today.

Sterrett-McWilliams House

Stairway in Sterrett-McWilliams Home, 1936. *Courtesy Library of Congress, Prints & Photographs Division, HABS, E.W. Russell. ALA, 66-Cam-5-4.*

The highlight of Judge Sterrett's home was an exterior framed by four impressive trellis supports and a remarkable rake parapet (a barrier at the edge of something; it comes from the Italian word *parare*, which means "to cover or shield." Parapets became popular in London during the early 1700s). Inside the home, twin cantilevered staircases curl up to the left and right of the foyer.

A cantilevered staircase only has support on one side, in this case the wall of the Sterrett-McWilliams home. The staircases have no supports underneath them or on their exposed side. Architects began using cantilevered staircases more than 350 years ago, which is quite an impressive architectural feat. Inigo Jones's 1635 Tulip Staircase in the Queen's House in Greenwich, England, is one of the earliest examples. Meticulously detailed plasterwork

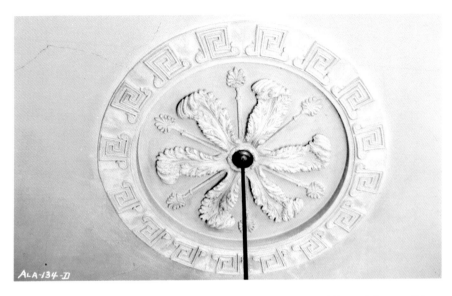

Delicate plaster work in Sterrett-McWilliams Home, 1936. *Courtesy Library of Congress, Prints & Photographs Division, HABS, E.W. Russell, ALA, 66-Cam-5-12.*

on the ceilings of the Sterrett-McWilliams home crown those staircases. The plasterwork was highly admired yet also caused great trouble and public humiliation for Judge Sterrett. For all the accolades that he received concerning his architectural masterpiece, it ironically revealed his selfish side and almost led to his ouster from town. His anti-Southern sympathies certainly didn't help either.

When relatives of Sterrett's wife (Susan McConnico Sterrett) died, leaving young children, Judge Sterrett was entrusted with the orphans and the financial means to care for them. "But instead of spending the money on the children, Judge Sterrett used it to make his home more grand, specifically to pay for all the ornate plasterwork," says Smith. The community was outraged when the scandal came to light, and there was talk of running Judge Sterrett out of town. However, Judge Sterrett died in 1858 of yellow fever before that could occur. Since his wife Susan had already died, the house passed into the hands of his only child, a daughter, Sally Brooks Sterrett, who lived in the North and couldn't afford the home's taxes.

In 1870, the home was sold by auction on the Wilcox County Courthouse steps. Smith's great-grandfather, a local merchant named Richard Ervin McWilliams, bought the home and several acres on Clifton Street for $3,500, the complement of which became known as the Sterrett-McWilliams Home.

Sterrett-McWilliams House

McWilliams, one of nine children, was a Confederate army major who fought in the Civil War from 1862 to 1865 while serving with Company B First Alabama Infantry, a unit known as the Wilcox True Blues. Union troops captured McWilliams twice, and both times he survived. On November 9, 1869, McWilliams married Amelia Lindsay Coate, a woman who gave him ten children during her fifty years, including Maude McWilliams Shook, the couple's youngest.

In 1917, Maude was visiting her sister, Marguerite McWilliams Cook, in Lansing, Michigan, when she physically saw something on display that she had mentally pictured many times, thanks to her father's numerous in-depth descriptions: the flag for the True Blues. The True Blues unit, one of the first companies to organize in Central Alabama, consisted of young enlistees from the eastern part of Wilcox County, as well as Camden. According to the Alabama Department of Archives and History, their flag was distinctive. The wives, mothers and sisters of the soldiers wanted to send them off with a proper flag, but since there was no appropriate fabric available in any nearby store, Miss Adele Robbins of Canton Bend donated her blue silk dress for the cause. Samuel Tepper hand painted the fabric with the name "Wilcox True Blues," as well as images of a steamboat, a cotton boll and a coiled rattlesnake. The True Blues proudly carried it away as they set out for Pensacola in the winter of 1861. Union troops confiscated the flag in April 1862 in Tennessee shortly after capturing the True Blues, including McWilliams. Upon seeing the flag in 1917, Maude immediately notified her father. After losing his wife in 1900, McWilliams had made locating the True Blues' company flag his life's quest. Upon learning Maude's news, McWilliams dedicated his last remaining years to enticing the State of Michigan to return the True Blues' flag.

On September 16, 1920, the Board of Governors of the State of Michigan and the Michigan Grand Army of the Republic agreed to return the flag to Alabama. On May 7, 1921, the McWilliams family presented the flag to the Alabama Department of Archives and History. Richard Ervin McWilliams died just a few months later on August 25, 1921, his quest complete.

He left his home to Maude, who became Maude McWilliams Shook. She never bore children, and upon her death, Maude McWilliams Shook willed the home to her sister Marguerite's children—son William (Billy) Manelius Cook and daughter Marguerite Cook Holt. They, in turn, passed it on to Billy Cook's two daughters, the home's present-day owners, Garland Cook Smith and Jean Lindsay Cook. The Sterrett-McWilliams House has been home to seven generations of the McWilliams-Cook family.

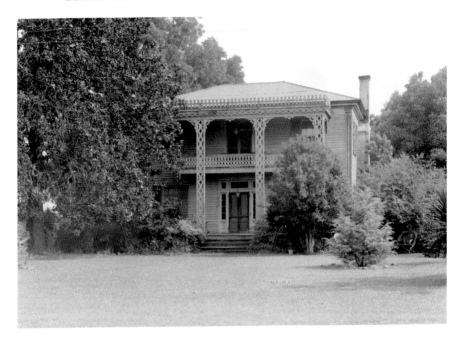

Front of Sterrett-McWilliams Home, 1936. *Courtesy Library of Congress, Prints & Photographs Division, HABS, E.W. Russell. ALA, 66-Cam-5-17.*

Many of the furnishings inside the house are family heirlooms passed down for generations. Garland Cook Smith's favorite feature in the home is the red Bohemian glass outlining the front door. "It's so dramatic when the lights are on. It makes such a statement," says Smith, a member of the Wilcox County Historical Society. The glass is made up of three panes—two red ones sandwiching a white one. During the antebellum era, glassmakers used gold to achieve the red tone, so panes of glass like this were more than a decorative statement; they also spoke to the owner's wealth. Smith is also especially attached to the home's original gasoliers in the symmetrical parlors, which sometimes seem to spotlight the scrolling acanthus leaves on the infamous plaster molding adorning the rooms.

The Sterrett-McWilliams home is often featured on the Wilcox County Historical Society's pilgrimage. It was added to the Alabama Register of Landmarks and Heritage in April 1992 and, along with the Wilcox County Courthouse Historic District, was added to the National Register of Historic Places in January 1979.

STURDIVANT HALL

Selma, Dallas County, 1852

A valued treasure since its beginnings, Sturdivant Hall glistens today in the Selma sun as a sanctuary for some of what time has stolen from the Old South—a respite of nostalgia in a world that has forgotten and distorted much of what that culture represented and endorsed.

In April 1852, planter Colonel Edward Watts purchased a sizeable lot in town on Mabry Street for $1,830. He then commissioned an architect believed to be Robert E. Lee's cousin, Thomas Helm Lee, to build a town home for him that was unique and ornate. Lee employed the help of two craftsmen from Italy to create exquisite plaster and marble designs throughout the ten-room, six-thousand-square-foot mansion. Made of solid brick construction, Carrara marble mantels and tiled marble floors grace the inside, and outside Corinthian columns outline the massive entranceway. The home's delicate ironwork was all handmade at Selma's foundry, which at the time was one of the largest in the South. The home has many unusual characteristics for its time, such as an L-shaped hallway and four suspended staircases. Mr. Watts, his wife Louisa and their children lived in the $69,000 mansion until February 12, 1864, when they moved to Texas and, as the legend goes, built a mansion identical to Sturdivant.

The new purchaser of the home was a twenty-six-year-old boy wonder of sorts named John McGee Parkman. One of Selma's native sons, Parkman learned what he could from his merchant father, Elias, and then went to work climbing the ladder of success in antebellum Selma. Parkman started out as a dry goods clerk and then, as the destructive war raged, managed to keep progressing and achieving, becoming a bookkeeper, bank teller and

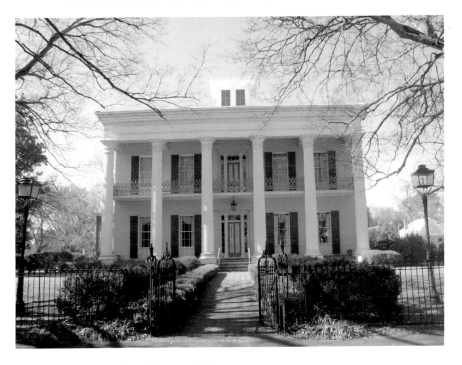

Exterior of Sturdivant Hall, February 2009.

bank cashier. Parkman and his wife, Sarah Norris (daughter of Calvin Norris of Mobile), moved into Sturdivant Hall, for which they paid $65,000, with their two young daughters, Emily Norris and Maria Hunter. The home was filled with love and excitement for the next three years as the two young girls explored their exquisite new surroundings.

The horrors of the War Between the States never physically touched Sturdivant Hall. Amazingly, it escaped the Yankee torches that were burning and destroying many other calling card buildings of the Old South's aristocracy. Indeed, Brigadier General James H. Wilson and his raiders marched through Selma, wiping out some two hundred homes. Experts now theorize that Sturdivant's survival is likely due to its small, charming neighbor, White-Force Cottage. The couple living in that home during the war were Clem Billingslea White and his wife, Martha Todd, half sister of Mary Todd Lincoln (President Abraham Lincoln's wife). Martha Todd White was known to cross enemy lines to deliver needed medicine and supplies to the Confederate troops, yet no harm ever befell her or her home. Many now speculate that Mary Todd Lincoln likely begged her husband to guarantee

Sturdivant Hall front entryway, 1935. *Courtesy Library of Congress, Prints & Photographs Division, HABS, Alex Bush. ALA, 24-Sel-1-5.*

her sister's safety. If President Lincoln had obliged and ordered the Whites and their home off-limits to the Union troops, they could not have risked setting Sturdivant ablaze, for fear that the flames would have spread to the White-Force Cottage as well.

Happiness and success surely seemed to be John Parkman's for the taking during those years, as in 1866 he was tapped to become president of the new First National Bank of Selma, which had a cash capital of $100,000. Tragically, though, Parkman's world was about to come crashing down.

The price of cotton was at an all-time high during the war years, as it was more difficult to get the South's "white gold" and therefore more expensive to purchase. The First National Bank of Selma, like many reputable financial institutions of the time, was heavily involved in cotton speculation. As the war ended, cotton prices crashed and many speculators were left financially devastated, including Parkman's bank. To make matters worse, the federal government had large cash deposits in the First National Bank of Selma, money that was now gone. Union general Wager Swayne rode to the bank one day, took control of it and arrested Parkman, sending him to prison in the nearby city of Cahaba.

Residents in Selma were outraged. They had watched Parkman grow up and steadfastly believed in his honest character. Such an insult, on top of the Union occupation, was unbearable. Parkman was devastated and supposedly swore never to leave Selma or Sturdivant Hall until he cleared his name. Some of the residents of Selma hatched a plan to free the imprisoned Parkman. They threw a grand Mardi Gras parade in front of the jail to distract the guards. The ploy almost worked. Parkman made it out of the jail, down to the river and was swimming across to his freedom when a guard looked up from the festivities and noticed him. The guard raised his gun and fired, killing twenty-nine-year-old John McGee Parkman.

Postwar times were incredibly difficult, and although Parkman's widow tried to hold on to her home, three years after his death—or murder, depending on who you ask—she was forced to auction off Sturdivant Hall for what little she could get for it: $12,500.

The third owner of Sturdivant Hall was a local baker and prosperous businessman, German immigrant Emile Gillman. Gillman had supplied the Confederate troops with bread during the war and quickly ingrained himself into the fabric of Selma society, also purchasing a fabulous Greek Italianate home known as Gillman Hall, not far from Sturdivant Hall.

Sturdivant Hall

Sturdivant Hall staircase and hallway, 1934. *Courtesy Library of Congress, Prints & Photographs Division, HABS, W.N. Manning. ALA, 24-Sel-1-6.*

Gillman's family owned Sturdivant for eighty-seven years, until 1957, but they actually stopped living there about 1947. During most of the 1950s, Sturdivant sat empty, except for the vandals who stripped it bare of everything except a few chandeliers and its gasoliers.

In 1957, locals who had always loved the home found a way to save the majestic old structure, then just a shadow of its formerly glorious self. Robert Daniel Sturdivant and his wife, Elizabeth Reese, left their elaborate assortment of antiques to the City of Selma upon their deaths, as well as $50,000 to find a place to house the collection. The City of Selma and the County of Dallas each contributed another $12,500, and with that the Sturdivant Hall Museum was born.

It actually took another decade to repair the home properly and turn it into a working museum. Today Sturdivant Hall, named for its benefactors, is truly a community treasure, a haven where many have come to donate the pieces of their family history so the past may live on in some sense for future generations.

Visitors to Sturdivant Hall will find themselves quickly whisked back through time to a world of jib windows, petticoat tables and silver services made to fit on a baby's high chair. Six wall panels entitled *Scenes of Venice* by French artist Horace Vernet greet visitors as they enter Sturdivant's doors. They are actually made from delicate old wallpaper found in New Orleans, carefully steamed off the walls and then framed at Sturdivant to look like murals. Portraits of various important Selma residents hang on the walls, watching over the house, donated by their relatives to be enjoyed and admired by more than just a few family members. Two of the portraits, featuring Mr. and Mrs. Edward Kenworthy Carlisle Jr., were painted by Nicola Marschall, who also designed the first Confederate flag and uniform. There is also a quilt made by Mrs. Jefferson Davis, a stunning floor-to-ceiling pier mirror belonging to the little Parkman girls and a French baby carriage similar to the one depicted in *Gone with the Wind* that Rhett Butler used to stroll around his Bonnie Blue. Some visitors report strange happenings and sightings inside the home; many museum staff members believe that it is the friendly ghost of John Parkman, making good on his promise not to leave his home until his name is cleared.

Outside, the old kitchen is now a gift shop, and the gates at the end of the backyard were brought over from the first White House of the Confederacy, which was in Montgomery. The three-door storage house for grain, wine and smoking meat sits tall and proud. A plantation office salvaged from the Fitts family's Roseland Plantation in Marengo County sits in between Sturdivant Hall and the White-Force Cottage, also now owned by the Sturdivant Hall Museum Association.

Despite all that has been done, Sturdivant Hall is a work in progress. Much is still being added to and planned for a home filled with many memories and mementos that tell the story of the families, a town and a way of life that has slipped mostly beyond our reach.

Sturdivant Hall was added to the National Register of Historic Places in January 1973.

Chapter 10

EVERHOPE

Eutaw, Greene County, 1852

E verhope Plantation is a magnificent three-story Greek Revival mansion whose owners have changed its name more times than they've renovated the structure. Originally known as the Captain Nathan Carpenter House, David Rinehart Anthony designed and built this home in 1852 using slave labor and timber from the plantation. Nathan Carpenter, the owner, was a true soldier, experiencing combat in the Mexican War (1846–48) while serving with the Eutaw Rangers and then again in the War Between the States with a unit he personally organized.

After finishing his year of service in the Mexican War, Carpenter, then twenty-two years old, married Catherine Cockrell in 1848, only to lose her to yellow fever the next year. In 1851, Carpenter's fortunes changed. At that time, he owned seven slaves. He married sixteen-year-old Marjorie Pippen, and the couple purchased 667 acres of land for $10,000 to begin building their five-thousand-square-foot dream plantation, highlighted by octagonal columns and side gables. The resulting mansion was practically a mirror image of Marjorie's childhood home, Pippen Place, which sat only a half mile from the Carpenter plantation. Fire destroyed Pippen Place in the 1980s.

The Carpenter household flourished in every way. By 1860, Marjorie had given birth to five children, the cotton crop was a financial success and the plantation was worth $44,000 according to U.S. census records.

However, the Civil War changed everything. In 1862, Carpenter, ever the soldier, called a meeting at his home and organized a company called the Confederate Rangers that would later become Company B of the Thirty-

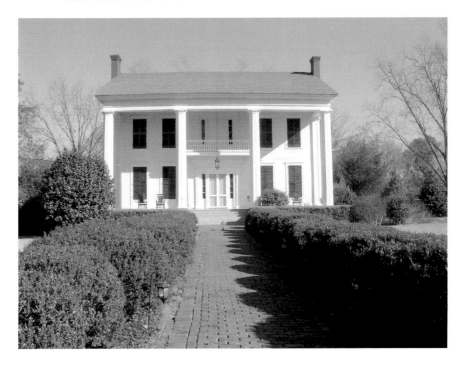

Everhope Plantation, January 2009.

sixth Alabama, CSA. The men elected Carpenter as their captain. The unit served under General James Thadeus Holtzclaw, a Montgomery attorney, in the Battles of Chickamauga, Mission Ridge and Lookout Mountain and in the campaign in Atlanta.

At the end of the War Between the States, Carpenter returned home and tried to piece his former life back together. He and Marjorie had three more children, but the postwar world was cruel to the regime of the Old South. Carpenter held on to his home, but in 1870, his land was only worth $6,000, about one-eighth of what it had been valued at before the war.

After Carpenter died in 1907 and Marjorie in 1911, their spinster middle daughter Fannie inherited the home. When Fannie died, she left the home to her nephew, Clifford S. Boyce, son of Latimer and Gertrude Carpenter Boyce.

Boyce truly loved the home and lived there most of his life, even inscribing his initials on a wood board on the third story. This floor was likely used for storage or large parties. Today there is still a rare built-in closet in this one-room floor, as well as the ceiling hooks from which the oil lanterns hung,

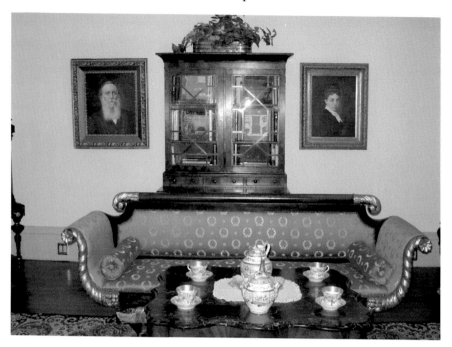

Everhope Plantation parlor, January 2009.

providing light decades ago. This third story offers an interesting clue as to how these magnificent homes were built so well and so quickly a century and a half ago. On the exposed third floor roofline, one can see wood peg construction (instead of nails) that is holding the timber beams together.

Clifford Boyce and his wife, Leah Graves, only had one child, who died at birth, so when Boyce died in 1974 at 95 years old, he didn't leave the home to anyone. After 122 years of being treasured by members of the Carpenter family line, the home, virtually unchanged since 1852, was abandoned.

In 1977, Dr. and Mrs. George E. Rudd bought the home, which still had no running water or restroom facilities. The Rudds arranged for the Captain Nathan Carpenter House to be listed on the Alabama Register of Historic Places, but they never moved in full time, only enjoying it occasionally on holidays and weekends.

The next decade was a lonely, scarring one for the Carpenter House. It sat empty, except for an occasional visit by vandals who left their marks by badly damaging the front door and stripping the Carpenter House of its magnificent chandeliers. Thankfully the home's shutters protected most

of the original wavy glass panes. The moldings, mantels and most of the hardware survived as well.

In 1994, the Carpenter House caught the attention of a commercial contractor who specialized in restoration. Charlie and Jan Bullock were struck by how architecturally unspoiled the home was: it had escaped any significant remodeling. Even the window frames bore their original coats of paint. The Bullocks bought the Carpenter House, renamed it Twin Oaks for the two magnificent oak trees that framed the home and went to work fastidiously restoring the home. For the next five years, the Bullocks painstakingly replastered the ceilings that were falling in, refinished the heart pine floors and repainted the dried interior and exterior wood—a process documented by the Home and Garden television network. The Bullocks also added central heat and air, but they were faithful in their commitment not to spoil Twin Oaks' unique antebellum authenticity. They even researched what exact shades were likely first used to paint the rooms in a valiant effort to reproduce the past as completely as possible. The couple at one point decided that the dining room's three pantries must have been added after the home was built, because most houses predating the Civil War did not have closets or pantries. Removing the pantries took about three hours as the Bullocks tried to restore the home's architectural purity. Much to the couple's dismay, the Bullocks later discovered that they'd made a mistake—the pantries were indeed original. Charlie Bullock then spent three weeks meticulously rebuilding them.

The Bullocks were even able to repair Twin Oaks' battered faux grained painted front door. Local painter Leo Sullivan matched his predecessor's workmanship so precisely that visitors today can't tell which door has been repaired. Twin Oaks is a magnificent example of the faux grain painting technique. In the mid-1800s, skilled artisans would spend hours using a peacock feather to paint a fake wood grain that looked like a more valuable tree, like oak or maple, onto locally indigenous wood, like pine. "Thankfully, amazingly, no one has ever painted over it in all these years," says Harmon. Today, one can see not only an elaborate display of faux grain artwork but also the initials "C.C." for Captain Carpenter, identifiable in several places.

The next chapter in Twin Oaks' history began in 2005, when David Harmon and his wife, Pam, decided to enjoy their retirement by selling their home in Atlanta and exploring the country in their motor coach. After three years of adventures, while on their way to New Orleans, the Harmons stopped in Eutaw, just for the night. "It was such a perfect small

Everhope

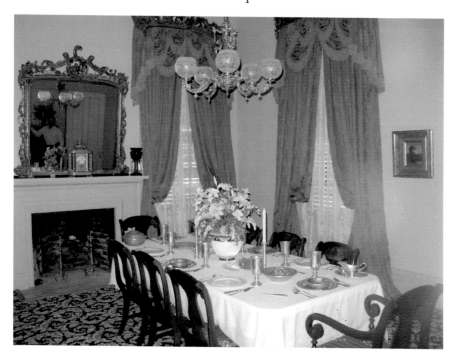

Everhope Plantation dining room, January 2009.

town: historic homes, friendly people, no Wal-Mart," says Harmon, who not only took a liking to Eutaw but also to Twin Oaks. "I absolutely fell in love with it. Something about these old homes you can't duplicate, no matter how fine of a modern home you build," Harmon explains. Here's where Harmon's dream hit a snag: Twin Oaks wasn't for sale. However, Harmon was determined to have the house, and he talked the Bullocks into selling it after explaining his passion for its continued restoration. The Harmons bought Twin Oaks and picked up renovations where the Bullocks left off.

The Harmons christened the home with its current name, Everhope, in 2007, when lightning destroyed one of the large oak trees that had served as the home's previous namesake. Since then, they have filled its rooms with period antiques: a spindle from the 1800s, coffee service from the 1850s, sideboards with real silver handle pulls. The Harmons have even preserved the replica antebellum patterns for the carpet in the gentlemen's parlor and the dining room drapes, which today puddle on the floor in the same manner they did in the 1800s—a tribute to the owner's wealth.

Everhope Plantation's silver tea set, January 2009.

The Harmons live at Everhope year round and open its doors to visitors who'd like to experience a piece of antebellum history. Everhope's original four-over-four design is unspoiled by modern conveniences. The Harmons live in a three-thousand-square-foot addition built onto the original house. The two areas are separated by a wide cross hall. The modern conveniences of everyday life—bathrooms, running water, etc.—are found only in the addition, preserving the originality of Everhope. "We couldn't intrude on the integrity of the home," says Harmon. Visitors are awed by Everhope's interior and intrigued by the property's outbuildings, which are the next step in the Harmons' restoration efforts. One of the slave quarters, part of the original detached kitchen, the tenant house and even the Colt Carbide Pit Generator (which produced gas for the light fixtures) have survived all these years. The large boxwood in the rose garden is believed to date back to the home's construction. Although the name is different, Everhope is a place where the antebellum past lives on as uninterrupted as possible, protected from the quickly changing world surrounding it.

Everhope was added to the National Register of Historic Places in 1999.

Chapter 11
HAWTHORNE HOUSE
Pine Apple, Wilcox County, 1852

T his two-story, wood-framed house was the childhood home of the youngest Confederate general in the War Between the States, a young man exposed early on to life's harsher side but who prevailed nonetheless.

The Hawthorne House's story begins before that though, with Joseph Richard Hawthorne, who commissioned Ezra Plumb to build Hawthorne House in 1852.

Hawthorne was born in North Carolina, reared in Georgia and moved to Conecuh County, Alabama, as a young teenager. In his book entitled *History of Conecuh County Alabama*, Reverend B.F. Riley writes about young Hawthorne:

> *Highly gifted with native powers, mental and physical, Mr. Hawthorne's influence was felt as he advanced toward the period of manhood's perfect mould. He was equal to the hardships incident to a frontier section.*

As Hawthorne grew, he lived up to Reverend Riley's expectations. Hawthorne became prosperous, owning several plantations, and well-respected as a man and civic leader. After the country's financial crash of 1837, debate locally and nationally turned to how to protect the economy from a future fallout. Missouri senator Thomas H. Benton proposed initiating a new currency of solely silver and gold. This turned into one of the premiere political debates of the new country: the Whig party was against the idea, the Democrats for it. In Conecuh County, Jeptha V. Perryman became the Whig's candidate for the state legislature,

and Hawthorne was tapped by the Democrats. Hawthorne's opponent began calling him "the Benton Mint Drop Boy," and a hot political race ensued. In the end, Perryman bested Hawthorne by just seven votes, and although the Democrats lost, the party was quite encouraged by such a close call with success. Despite defeat, Hawthorne left the political ring with his reputation galvanized. Reverend Riley writes of Hawthorne's adulthood:

> *No man who has ever lived in Conecuh exerted a broader or more wholesome influence, than did J. Richard Hawthorne. His zeal in all matters relating to the public weal was proverbial. Generous, hospitable as a prince, warm-hearted and public spirited, and above all, a devout Christian gentleman, his usefulness is destined to be commensurate with his days.*

In his late forties, though he did not sell his property in Conecuh County, Hawthorne moved again, this time to Pine Apple in Wilcox County, where he began another grand plantation and built his dream home. Hawthorne House is a heart pine masterpiece resting on pine sills measuring more than fifty feet in length. The four-over-four design features a grand entrance of square columns, porticos, balconies, three doors and large windows. Hawthorne once again heard the call to civic duty in his new home, representing Wilcox County for two terms in the Alabama legislature.

Hawthorne was also a family man. He was married three times, first to Elizabeth Patience King of Mobile, then to her sister, Sarah C. King, and then to a widow by the name of Harriet Herbert. In 1847, Herbert's daughter, Elizabeth Herbert Kelly, died. Elizabeth's husband, Isham Kelly, had died three years before while on a trip to Cuba. After Elizabeth's death, the couple's two young sons, John and Rollins, came to live with their grandmother at Hawthorne House. Little John Herbert Kelly was four when his father died and seven when his mother died, and not too long after that, he buried his brother Rollins, too. Despite so much tragedy at such a young age, John Herbert Kelly grew to be an impressive young man under the care of Joseph Richard and Harriet Hawthorne.

When John Kelly was seventeen years old, his uncle, Congressman Philemon T. Herbert, and other influential relatives helped him secure an appointment to West Point. His class was quite an impressive one, including Judson Kilpatrick, John Pelham, Emory Upton and George

Hawthorne House

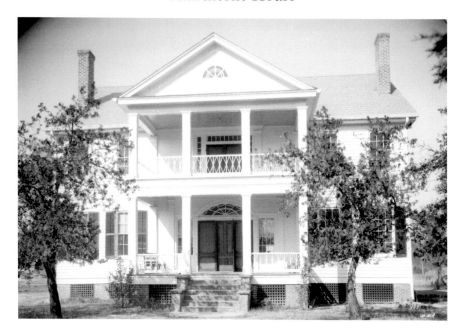

Hawthorne House, 1937. *Courtesy Library of Congress, Prints & Photographs Division, HABS, Alex Bush. ALA, 66-Pina-1-1.*

Armstrong Custer. In December 1860, Kelly was a standout cadet, set to graduate in just a few months, when the Southern states, starting with South Carolina, began seceding from the Union. Kelly, like many of his classmates, tendered his resignation and left West Point to answer the call of duty at home.

Kelly traveled immediately to Montgomery, Alabama, where he became a second lieutenant of artillery in the Confederate army. His duties took him to Fort Morgan, then to Missouri with Brigadier General William J. Hardee. Kelly rose quickly through the leadership ranks: a captain in October 1861—he simultaneously accepted the responsibilities of assistant adjutant general—and then a major with the Fourteenth Arkansas Infantry. By April 1862, Kelly was at the helm of the Ninth Arkansas Infantry, which he gallantly led through the Battle of Shiloh, capturing a Union battery. One month later, that success led to another promotion, this time to colonel of the Eighth Arkansas Infantry. Kelly led men from Kentucky, North Carolina, Virginia and Georgia in battles such as Perryville, Murfreesboro and Chickamauga, even having a horse shot out from beneath him. His superior, Brigadier General William

Preston, wrote in his official report: "During the struggle for the heights, Colonel Kelly had his horse shot under him, and displayed great courage and skill."

Some of Kelly's superiors began pressing for another promotion for the young man, but competition was fierce. Lieutenant General James Longstreet of Tennessee was advocating a soldier with much more experience than Colonel Kelly, Colonel Robert C. Trigg. However when General Braxton Bragg weighed in, favoring the younger colonel, Kelly became a brigadier general on November 16, 1863, making him the youngest general in the Confederacy. Just before Kelly's promotion, he was reassigned to command a brigade in Major General Joseph Wheeler's cavalry division.

Some speculate that this transfer may have been caused by Kelly's decision to sign a memo by Major General Patrick R. Cleburne advocating emancipating any slave who agreed to fight for the South's cause. Nonetheless, Brigadier General Kelly led his troops through the Atlanta campaign and on to Tennessee. On September 2, 1864, Kelly was leading a raid on Union General William T. Sherman's communication lines near Franklin, Tennessee. Legend says that there were certain Yankee sharpshooters looking for the South's "Boy General" that day. One of their bullets made a direct hit on Kelly's chest. He was carried off the battlefield to the Harrison House in Franklin where, two days later, he died on September 4. The one-time orphan who buried all of his immediate family as a child, now Brigadier General John Herbert Kelly, left this world at twenty-four-years-old.

Locals bought Kelly a coffin and new clothes to go under his uniform coat and buried him in the gardens of the Harrison House, the same home where, months later, the Confederates brought their generals killed during the Battle of Franklin. In 1866, Brigadier General Kelly came home to Alabama, reinterred in Magnolia Cemetery in Mobile, where General Braxton Bragg is also laid to rest.

Back in Pine Apple, Kelly's grandmother and her husband were struggling to cope with the new postwar South. One of the biggest landowners in the state before the war, Hawthorne decided to donate land to former black slaves in 1869 for them to build a church. It became known as the Arkadelphia Baptist Church. After Hawthorne's death in 1889, the home was left to his daughters but was sold out of the family.

In 1935, one of Hawthorne's descendants, Dr. Julian Hawthorne, made arrangements for its purchase. Dr. Hawthorne was a successful New York

Hawthorne House

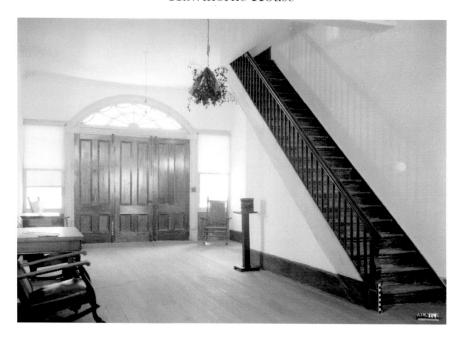

Hawthorne House staircase and main hall, 1937. *Courtesy Library of Congress, Prints & Photographs Division, HABS, Alex Bush. ALA, 66-Pina-1-5.*

obstetrician, who, although a member of the Westchester Country Club and other New York City social organizations, had always held on to his love for his hometown of Pine Apple. He purchased and restored the Hawthorne House and moved his sister Gladys Hawthorne Whitaker in to care for the refurbished gem. Dr. Hawthorne's visits to Pine Apple were always the talk of the town, especially when he came to hunt, often bringing friends from the city and hosting grand game dinners.

After Gladys Hawthorne Whitaker died, Dr. Edward Childs and his wife, Jackie, purchased the home in 1985. Antebellum architecture was originally Jackie's passion, but it has now infected Dr. Childs as well. The couple had been looking for an antebellum home when friends informed them that the Hawthorne House would soon be going on the market. The Childses purchased the Hawthorne House before it was advertised and before they knew of its rich history. "It was only after we bought it that we learned what a treasure we really had," says Dr. Childs. By this time, the Hawthorne House had again fallen into severe shambles. The Childses first renovated the caretaker's cottage, adding a kitchen and bathroom. That's where they still stay as they continue to work on bringing the Hawthorne House back to

Hawthorne House stable. *Courtesy Library of Congress, Prints & Photographs Division, HABS, Alex Bush. ALA, 66-Pina-1-16.*

life. "There's an awful lot to do. It's a never-ending labor of love," says Dr. Childs. The couple has ambitious plans for the property, including a pond and an arbor of fruit trees. "I'm delighted. It's a real source of pleasure. You feel fortunate to have the opportunity to be a caretaker, to be honored with taking care of the past. We want to preserve it for the next generation," says Dr. Childs.

Hawthorne House was added to the National Register of Historic Places in March 1985.

Chapter 12
LIBERTY HALL

Camden vicinity, Wilcox County, 1855

L iberty Hall's story is a testament to the strength, character and ability of the American woman, both yesterday and today. Although the home's graceful beauty is as impressive as its counterparts, it's the story of the women who have lived in Liberty Hall that makes the home so truly grand.

W.W. Robinson built this two-story, four-over-four, Greek Revival mansion in the early to mid-1850s for a man of Scottish descent named John Robert McDowell. Astute visitors will immediately notice that the home is framed by two round columns and two square columns. While building the home, Robinson had arranged for four round columns to be shipped up the Alabama River to Camden, but a nasty storm tossed the cargo boat around so fiercely that two of the four round columns were lost. Robinson improvised with the two square columns instead. McDowell's wife, Harriet Sellers McDowell, was a true lady who embodied all the talents, disciplines and manners of an antebellum mistress. Sara Harris, now eighty-eight years old, the current and fourth-generation owner of Liberty Hall, remembers it fondly:

> My mother, Narcissa Goree McDowell, used to tell me stories of how, as a child, she loved going to Liberty Hall to sneak in a ride down the banister when she thought no one was looking. Of course, her grandmother, my great grandmother Harriet, hated that because it wasn't befitting of a proper lady, no matter what age she was. My great grandmother begged, scolded and lectured my mother. She finally resorted to giving her a fifty-cent piece to make her behave.

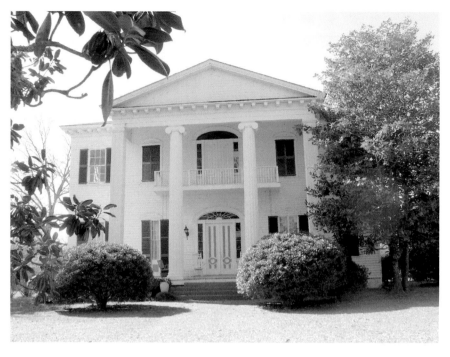

Liberty Hall, February 2009.

Harriet McDowell is responsible for all of the delicate plasterwork outlining Liberty Hall's tall ceilings. She hand crocheted every inch of design and then had it dipped in plaster, dried and attached to the ceilings. John and Harriet McDowell had four children: Frances, who died as a child; Samuel William; Harriet; and Elizabeth. John and Harriet McDowell died within a few weeks of each other in late January and early February 1897. Their son, Samuel William McDowell, inherited Liberty Hall, which at that time was known as the McDowell House.

Samuel was married to Julia Zimmerman Tait, daughter of Felix and Narcissa Goree Tait of White Columns Plantation just down the road. Samuel and Julia McDowell were the proud parents of Narcissa Goree McDowell (Sara Harris's mother), the little girl who loved to slide down Liberty Hall's banister.

Samuel and Julia McDowell were living in Liberty Hall when the War Between the States erupted. They hid the family silver in an empty space in one of the round columns. The compartment's outline is still visible today. When the Union troops pulled into Camden, they intended to torch

Liberty Hall

Liberty Hall staircase, 1937. *Courtesy Library of Congress, Prints & Photographs Division, HABS, Alex Bush. ALA, 66-Cam. V-9-5.*

grand Southern homes like Liberty Hall. Local legend says that Liberty Hall was spared because when Samuel, a member of the local Masonic Lodge, walked out to greet the Yankees, he discovered that the officer in charge was a Mason as well. That officer decided he could not destroy a fellow Mason's home and supposedly ordered his men to pass over Liberty Hall, leaving it unscathed.

After Samuel McDowell died in 1900, followed by his wife Julia in 1907, Liberty Hall passed into the hands of their eldest daughter Narcissa, who had loved the home since her childhood days of conquering the banister. She married William Peyton Harris Sr. on December 26, 1908, at Liberty Hall. The couple then moved a few miles away to Possum Bend, where they had five children: William Peyton (1909), Julia Zimmerman (1912), Mary Emma (1917), Sara Narcissa (1920) and Henry "Demp" Franklin (1923). In 1925, the family returned to Liberty Hall. "I can clearly remember that wagon ride. It was so bumpy, yet so exciting," recollects Harris.

Here begins the story of two amazing women, a mother and a daughter, who broke barriers for the times they lived in and opened doors for the

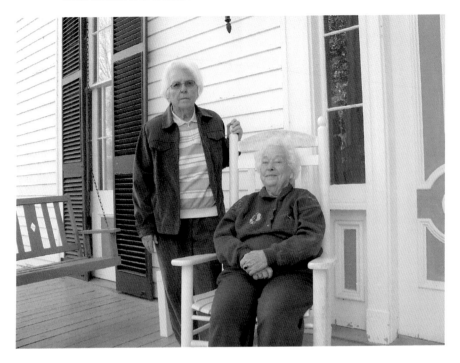

Sara Harris and Mary Gogbold, Liberty Hall, February 2009.

women who came after them. Family fortunes had dried up, and life was hard for Will and Narcissa Harris.

It's a time that Sara Harris and her sister, Mary Gogbold (now ninety-two years old), remember well. "Mother sent us children out to trap animals. We then skinned them and sold their fur for money. It was an awful thing to do, but money was so hard to make," says Harris. Although the girls didn't know it at the time, their father Will, a talented artist—especially when it came to woodwork—was also a heavy drinker and a bold gambler. He lost or drank what little money the family had coming in from the animal furs and a small store that they operated across the street from Liberty Hall.

In 1933, when Sara Harris was thirteen, her father left. Her mother Narcissa was determined to hold on to her children, her family home and her dignity, but the challenge was tremendous. When Will Harris left, he had mortgaged Liberty Hall and bankrupted the family store. With a spirit that would have impressed Scarlett O'Hara, Narcissa Harris and a servant began to work Liberty Hall's fields from sunup until sundown, planting cotton and

vegetables. Narcissa also tried her hand, most successfully, at raising cows and pigs. "She would send us to town with the eggs, to either sell them or trade them for things like haircuts," recalls Mary Gogbold.

Slowly, Narcissa paid off Liberty Hall's mortgage, thanks in part to the family store that she had also found time to reopen and rebuild on her honest reputation. "All the negroes came to mother to do business at our store. They knew she wouldn't cheat them, which is something they couldn't necessarily say of other white folks," says Harris. However, money was by no means plentiful. "We were so terribly poor. It's awful to be poor and hungry. I can remember at Christmastime: mother would heat bricks in the fireplace and wrap them in towels. We'd hold on to them as tightly as we could to keep warm as we drove that old Model T to town to Christmas shop," says Gogbold. The children's gifts were toothbrushes and toothpaste.

Narcissa Harris instilled in her children a deep work ethic and an unfaltering sense of pride. "One day, the school offered us free lunches, and we were quite excited because we normally didn't have any food to bring to school. We ate breakfast and dinner at home and that was all. But when mother heard, she refused to let us accept the free lunches, sternly explaining, 'We do not accept charity,'" says Harris.

Even though Will and Narcissa Harris were divorced, their daughters say that they continued to love each other deeply until the day they died, and Will Harris came to see his children often. He expressed his love for his family through gestures such as elaborate hand-carved boats large enough to carry the entire family, a gift that Narcissa Harris didn't have time to appreciate or use with five children to feed and a plantation to save. Perhaps it was the weight of such responsibility, but Narcissa Harris's children never saw much of the young girl who used to slide down the banister when she could escape Harriet McDowell's watchful eye. "She was so dedicated to us, but she was stoic and didn't show affection like people do today. I don't know that she hugged us much, but we knew we were incredibly loved," says Gogbold.

Narcissa Harris, ever creative, found ways to tell her children that she loved them without using the words, and that is how Liberty Hall came into its present-day name. While other parents were strict and unrelenting on matters of decorum and behavior, Narcissa Harris gave her children what she yearned for growing up, free reign of the home and its grounds:

She let us and our friends do most of the things little children want to try, especially when you live out in the country in a mansion. Soon, everyone

wanted to come to our house to play because it was so much more fun than their homes. We children at that time all decided to rename the McDowell House "Liberty Hall."

Although Sara Harris's childhood is no doubt staunchly different from what most would picture of a southern girl growing up in a grand mansion on her family's plantation, she says that it was nonetheless joyful and, in the end, tremendously helpful in preparing her for adult life.

Sara Harris was determined to educate herself upon finishing high school, so she took out student loans and in 1944 graduated from the University of Montevallo near Birmingham. She was offered a job as a teacher for ninety dollars per month. "I thought about it, but it sure seemed like it would take a long time to pay those student loans back," says Harris. Instead, a different profession caught Harris's attention, one that only paid twenty dollars per month but held the promise of untold adventure: the Women's Army Auxiliary Corps, later known as the Women's Army Corps or WAC. "They were just allowing women in the military, so I signed up as a private and very soon shipped out to Europe with a company of five hundred other women. We worked every job you could think of," says Harris.

Her hard work and leadership skills quickly earned Harris a promotion to the rank of lieutenant. At that time, she was stationed about twenty miles outside London. As World War II raged, Harris received a surprise visit that she's carried with her all her life. Her younger brother Demp, who played football for the Washington Redskins before enlisting, was serving as a medic under General George Patton's command not far from Harris. He earned a day pass and came to see his sister, much to the delight of her fellow female soldiers. "He was only there for about eight hours, but my goodness, they really flattered him," says Harris with a smile.

Harris stayed in WAC until the organization shut down, because the legislation creating it called for its demobilization six months after World War II was officially declared over. "The government decided we were too much trouble," says Harris. She returned to Wilcox County and went to work in the journalism field for her sister Mary's husband, Stanley Gogbold, who was a lawyer and owned the local paper, the *Wilcox Progressive Era*. Although grateful for a job, the paper and Wilcox County proved mundane for Harris.

When, at the urging of General Dwight Eisenhower, President Harry Truman signed the Women's Armed Services Integration Act on June

Liberty Hall

Sara Harris, owner of Liberty Hall, standing at attention, wearing her battle helmet, February 2009.

12, 1948, Harris jumped at the chance to reenlist. The Women's Armed Services Act not only established WAC as a permanent part of the army, but it also opened other braches of service to females. Harris decided to try the U.S. Air Force. "I loved being in the service. It was so much fun, so much adventure," says Harris. The service, however, did not always love Harris or her fellow female soldiers. She had to prove herself many times, yet in each instance, she rose to the occasion in spectacular fashion, even when she was set up to fail.

After several years, Harris began asking for a promotion to company commander. Weary of her constant requests, one of Harris's male superiors decided to silence her by promoting her into what he thought would be a disastrous situation for a white woman from the South: he tapped Harris to be the commander of a company made up entirely of black females. "Well, that was like throwing Br'er Rabbit into the briar patch," laughs Mary Gogbold. "That man thought Sara would be full of prejudices and fail miserably. He had no idea we grew up playing with black children as our dear friends, that the black people of this area were the ones that saved my

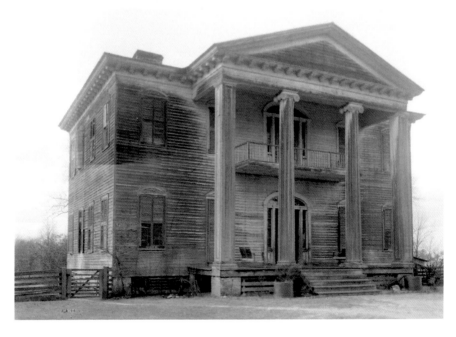

Liberty Hall exterior, 1937. *Courtesy Library of Congress, Prints & Photographs Division, HABS, Alex Bush. ALA, 66-Cam. V-9-1.*

mother's store. Those women all worked their hearts out for each other! You never saw a group more dedicated to each other."

Harris went on to become a lieutenant colonel and see combat in Vietnam, the first combat zone to allow female soldiers. That was Lieutenant Colonel Harris's final military assignment. Before Harris returned home, the people of Vietnam presented her with a traditional hat, as well as a bow and arrow. Her fellow soldiers gave her an honorary rifle, since at that time women did not carry weapons. After more than three decades of military service, Harris retired with a happy heart. "I am so grateful for my chance to serve my country and experience all that I did. I wouldn't trade a million dollars for a second of it," says Harris.

In the early 1980s, Harris returned home to Wilcox County. Her brothers and sisters voted to give her Liberty Hall, since they all had homes and since the house needed Harris as much as she needed a place to live. Since then, Harris has channeled her tireless energy into restoring her family home. "I have a lot of respect for this home. We all love it," says Harris. From repainting to recaulking to restoring and reinforcing the plasterwork that her great-grandmother inspired a century and a half ago, Harris's work is never done. "If I can leave it just a little better than I got it, I'll be happy," says Harris.

Liberty Hall was added to the National Register of Historic Places in January 1984.

Chapter 13

ROSEWOOD

Lowndesboro, Lowndes County, 1855

T he drive into Lowndesboro is an eerily beautiful one, past miles and
 miles of heavy Spanish moss that seems more suited to the swamps
of south Louisiana than central Alabama. Upon arriving in town, one is
greeted by dozens of historical structures: mansions, churches, cottages,
schools and cemeteries. Through the thick moss, toward the edge of town,
one can barely make out the edges of what looks like a staircase, a dual
staircase. This is Rosewood.

Dr. Hardy Vickers Wooten commissioned the raised cottage French
colonial villa in 1854. The bricks are the work of slaves' expertise; the lumber
was hauled in from Picket's Mill in Autauga County. The home cost $4,800
to build, a little more than half of what Dr. Wooten made from his cotton
crop the year before. The home is highlighted by its pillared portico with the
striking dual staircases curling down on the sides, effectively framing three
arches on the bottom story that form a loggia (a roofed gallery with open
sides). It has five chimneys but ten fireplaces. In his diary, which is now in the
Alabama State Archives, Wooten writes, "It is exactly to my notion. I mean
the arrangement, size of rooms, etc."

Wooten was originally from Georgia, a graduate of the University of
Pennsylvania School of Medicine who came to Lowndesboro in 1837 at
twenty-four years old after hearing of the growing population and friendly
people. "Lowndesboro was very high society back then. Large, wealthy
landowners from South Carolina came here to plant cotton," explains
Richard Williams, one of Rosewood's current owners, who is now retired
after a thirty-seven-year career with Regions Bank. Despite numerous

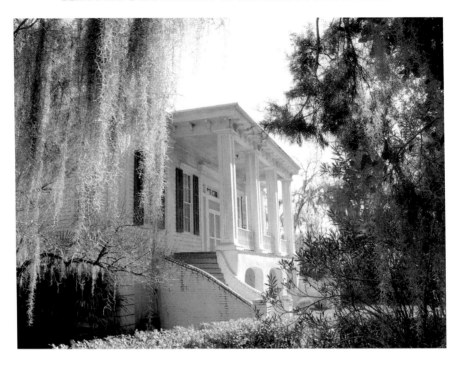

Rosewood Plantation, January 2009.

offers to teach at various medical schools, Wooten served the people of Lowndesboro for twenty years, deciding to build Rosewood in 1854 for his wife, Charlotte, and five children, three girls and two boys, one of whom was killed in battle during the Civil War.

Wooten not only delighted in the architectural results of Rosewood, but also in the plantation's garden, which is one of the first formal gardens in the Deep South and Alabama's first documented garden, thanks to Dr. Wooten's meticulously detailed diary. The Wootens began working on their garden in February 1856. It's highlighted by three circular flowerbeds, one for each daughter, planted on February 2 and a cherry laurel hedge planted on February 9 in the shape of a "W," for Wooten. Other accoutrements included twenty-two cedar trees that still line the driveway today, a hedge of flowering almond and a star magnolia.

Wooten was also an author. Many of his works appeared in literary magazines such as *The New Yorker*. He was a staunch believer in states' rights, yet he opposed dissolving the Union. Tragically, Wooten was only able to enjoy his mansion and beloved gardens for nine months. He contracted

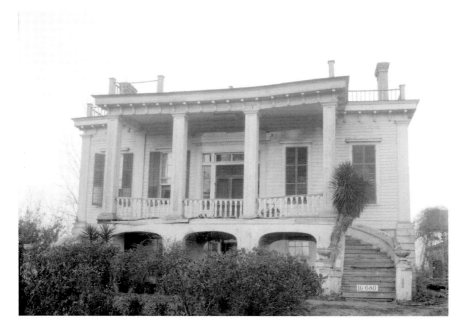

Rosewood Plantation, 1934. *Courtesy Library of Congress, Prints & Photographs Division, HABS, W.N. Manning. ALA, 43-LOWB-8-1.*

tuberculosis and died at age forty-three on July 19, 1856. Wooten's descendants, mainly grandson Alphonzo Meadows and great-granddaughter Lilyclaire Williams, have added to the garden, carefully ensuring that they abided by the integrity of the design laid out in Wooten's diary. Today, crape myrtles, camellias, azaleas, dogwoods, periwinkle, wisteria and baby's breath blossom throughout the gardens. Many of them were transplanted decades ago from the nearby woods. One camellia bush on the side of Rosewood has grown to resemble a tree, towering close to the second-story level. Ironically, Rosewood received its name not from any of these carefully tended plants but from the wild McCartney's and Cherokee roses that grew naturally on the land.

Rosewood played a starring role in Lowndes County's Civil War experience, much to the dismay of the Wooten family. Union brigadier general James Wilson and his company of approximately fourteen thousand men—known as Wilson's Raiders—were sweeping across much of Georgia and Alabama at this time, conquering, destroying and stealing. After Wilson's Raiders burned most of the cotton bales in Selma waiting to be shipped down river, they headed for Montgomery on a path that would have taken them through

Lowndesboro. A local doctor tried to save the town by warning General Wilson that a smallpox epidemic had swept through town. General Wilson fell for the story and, instead of going into town, instructed his troops to camp on the side of town, next to Rosewood.

Some of the Yankees proved boisterous, riding their horses through Rosewood's hall and frightening the ladies. Mrs. Wooten wouldn't stand for it and immediately drafted a letter to General Wilson, scolding his troops' lack of decorum. Wilson not only obliged her by instructing his troops to behave, but he even sent two guards to ensure that Rosewood was not a source of childish entertainment for his men. The two guards happened to be young and striking, so as they stood watch, the Wooten girls repaid them by inviting them into the parlor, where they sang and played the piano on the soldiers' behalf. Despite those gestures, the Union troops still aimed to ransack the home upon their departure. They tore the blue silk curtains out of the family's carriage and gustily sang "The Bonnie Blue Flag." They plundered through the property looking for valuables, but Rosewood's quick-thinking slaves had already hidden the horses and silver. The Yankees did insist the that mammy (usually the head domestic slave who ran the plantation house) pour all of the home's molasses, flour and meal into a pile on the floor and then round up all of the plantation's turkeys for a roasted dinner they could carry to camp. The mammy begrudgingly did as she was told but had her revenge, leaving all of the gall inside the birds so they were too bitter to eat. As General Wilson pulled out of town, a few of his men lagged behind, only to meet a crowd of angry locals. They shot one soldier and then forced the other to dig the two men's graves before they hanged him. Both are buried underneath one of the cedars lining Rosewood's driveway.

Unlike many of its contemporaries, Rosewood has never left the family, although some owners have only been related by marriage. Four families have called Rosewood home: the Wootens, the Howards, the Meadowses and the Williamses. Rosewood has only had five mistresses: Charlotte Rochelle Wooten, Ella Wooten Howard, Mary Eloise Chapman Meadows, Lilyclaire Meadows Williams and Linda Lee Williams. Therefore, Dr. Wooten's prized "W" shrub in the garden worked well for almost everyone, because it could either be a "W" or an "M" depending on which direction you were looking from.

After Charlotte Wooten's death, Rosewood passed into her daughter Ella Howard's hands. Ella and her husband, Mark Howard, used Rosewood as their primary residence. When Ella died in 1918, Mark's nephew, Alphonzo

Rosewood

Chair handmade by a Rosewood slave, January 2009.

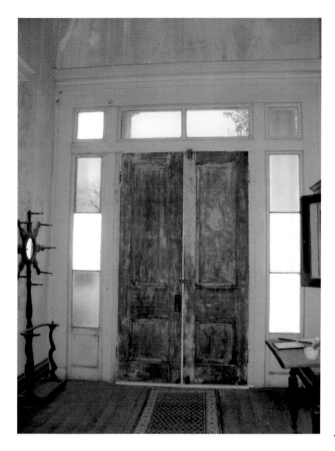

Doorway to Rosewood
Plantation, surrounded
by colored glass,
January 2009.

Whitaker Meadows, and Mary Eloise moved in to help care for Howard and the home. They had Rosewood wired for electricity in 1920. Their daughter, Lilyclaire, inherited Rosewood in 1962. Lilyclaire, a gentle schoolteacher who loved Rosewood and spent years building its gardens, raised her three sons (the present-day owners) in Rosewood: Gene and identical twin brothers Richard and Ransom. Richard and Linda Williams live in and tend to Rosewood today. They moved into Rosewood in 1989 to care for Lilyclaire and Oscar Williams, as they were advancing in age and the plantation had become too much for them.

Richard's room as a child was Rosewood's original dining room. "We had plenty of room to cavort and ride horses. We did a lot of bird hunting because there were no deer back then," he recalls. His dedication to Rosewood is partially in honor of his mother Lilyclaire. "This home was her pride and joy. She and my granddaddy invested so much time into

this land and these walls," says Williams. In her younger years, Lilyclaire began working alongside her father, Alphonzo Whitaker Meadows, restoring Rosewood's gardens. She left home to attend Howard College but returned just two short years later because her mother, Mary Eloise, Rosewood's third mistress, had died. Lilyclaire's father, Alphonzo, was then left alone to care for both Rosewood and Mary Eloise's elderly mother, Lilly Chapman. Lilyclaire moved home immediately to help shoulder the load while finishing her studies at Huntington College. "She was a great lady," smiles Williams. Lilyclaire then stayed home, raising her three sons, and when they were grown, she returned to college to get her teaching degree. "She ended up graduating the same day in 1956 as my brother Gene did from the Naval Academy. We all went to Annapolis to see his graduation and had to skip hers," says Williams. Lilyclaire spent the next twenty-five years teaching first and second grade at Catoma Elementary in Montgomery County.

The Williamses live in the downstairs, low-ceilinged rooms of Rosewood's basement, which is two feet underground and which originally served as Dr. Wooten's office. This bottom level is heated by gas space heaters. The

Richard Williams, owner of Rosewood, January 2009.

upstairs, boasting sixteen-foot ceilings, has been unchanged, preserved as a tribute to the past. There are three rooms on either side of the hall on the second story, plus an attic and an observatory. The stained-glass sidelights are all original except for one that needed to be replaced. The Williamses are doing their best to continue restoring and therefore preserving Rosewood and their family legacy, but it is an expensive, exhausting task. "In 2008, we spent $10,000 just to repair the upstairs windows after damage from Hurricane Ivan. It took five weeks to recaulk and reglaze them," says Richard Williams. Rosewood now holds a treasure trove of family antiques, including the piano the Wooten girls played for the Yankee guards; vases originally belonging to Dr. Wooten; a Latin book dating back to 1500; a tester bed that the Wootens had shipped in from England; two chairs—one with a deer hide seat, one with a cane seat—hand crafted by Rosewood slave Sam Meadows; a wooden utensil carrier brought over on the *Mayflower*; and a bookcase filled with medical books belonging to Dr. Wooten.

Rosewood at one time included 1,800 acres. Now the Williams brothers oversee 600 acres, much of which they've planted with pine trees. Rosewood's pine tree forests have earned the state distinction of treasured forest status, an honor that Alabama bestows on families using their land to preserve trees and wildlife habitat. It's a theme that's been echoing through Rosewood's halls for generations.

Chapter 14

REVERIE

Marion, Perry County, 1858

P erry County's Reverie is an ornate jewel decorating the streets of Marion that sweeps visitors under its spell with the promise of an authentic taste of the genteel Old South that has been mostly lost to time. Reverie was patterned after the White House of the Confederacy in Richmond, Virginia. This Greek Revival masterpiece is as magnificent inside as it is outside; her storyline rises and falls as it mirrors the triumphs and heartbreaks of the Deep South's history.

The first known record of Reverie begins in February 1842, when Hugh Davis purchased what was then known as the "McKinney Lot" for $718.52. The almost two-acre lot had nothing on it except some impressive plant life, some of which, botanists believe, still exists today. Reverie is home to an astoundingly large wisteria vine that dates back to circa 1838, twenty years before Reverie was built. On February 9, 1858, Davis sold the otherwise empty lot to planter and railroad investor Joseph Thompson Whitsett. Perhaps it was the wisteria—Whitsett agreed to pay the impressive purchase price of $4,000.

Whitsett went on to build a mansion of monumental proportion and detail. The four Doric columns framing the home are built of stucco-covered brick. They support a traditional widow's walk and classic balustrade (the small posts supporting the railing of the widow's walk). Reverie is wrapped in massive frieze board (making the house appear taller while also sealing it from unwanted air flow and insects) with dentil moldings. Inside, the pocket doors in the parlor still bear Whitsett's name on a set of shipping instructions handwritten in India ink.

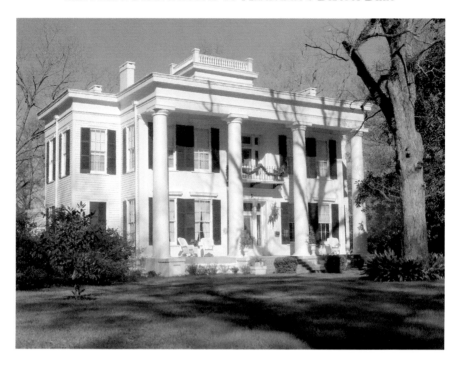

Reverie Mansion, January 2009.

The delicate detail applied to the inside of Reverie is striking. The floors throughout the home are heart pine, and their thickness measures an inch and a half. The front bedroom and hall sport an intricate log cabin pattern made out of inlaid oak and mahogany that was likely time consuming to fashion. Fabulous plaster ceiling medallions and cornices adorn many of the rooms. Reverie originally had two main staircases: a curving, unsupported one that still greets visitors today as they enter the main hallway and a more private one that used to spiral up from the den to an upstairs bedroom before it was removed. Some historians say that a staircase like this could be used to keep the boys and girls separate; others speculate that it was simply a more private way to travel from a downstairs office up to a bedroom without entering the home's public areas.

Reverie enjoys a unique feature for its time—six cabinet rooms (large closets sans the doors), two large ones downstairs and four small ones upstairs, adjoining each of the bedrooms.

The War Between the States stressed the hearts, minds and fortunes of the families of the Deep South from the beginning, and the Whitsett family was no exception. In November 1862, as the value of his assets and

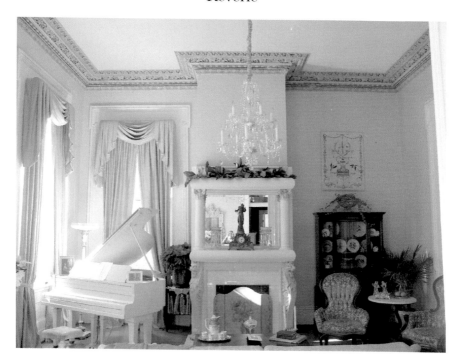

Reverie Mansion parlor, January 2009.

investments began to plunge, Whitsett and his wife Eliza sold Reverie to Edwin Kenworthy Carlisle for $10,000 just four years after building their magnificent home. It seems that Carlisle purchased Reverie either to help a friend who had fallen on hard times or for sheer investment purposes, as he and wife Lucinda Wilson Walthall had just finished building the remarkable Italianate-style Kenworthy Hall on the outskirts of Marion in 1860.

Carlisle sold Reverie five months later to South Carolina–born businessman David Scott for $12,000. Scott's head for business led him to own a brick storehouse, a mercantile and a water-powered cotton mill near what is today known as Centreville in Bibb County, all prior to Scott's purchase of Reverie. Scott is credited with being one of Alabama's first industrialists, and in the late 1850s, the town where the cotton mill sat became known as Scottsville. It had a hotel, a general store, a blacksmith, a carpenter, a sawmill, a gristmill, a church and cottages. Scott did have partners, although he was the one who lived in Scottsville to run the mill. The partnership had enormous wealth for that day: three thousand acres and $117,000 of capital stock, which included $25,000 in slaves and $16,000 worth of goods in the general store.

Scott was married twice, both times to wives from the North: Stella Houghton (1802–1844) from Vermont and later Elizabeth "Eliza" from Massachusetts. These two marriages gave Scott nine children. Scott's fortunes would soon change drastically, courtesy of the Yankee army. Just two years after Scott purchased Reverie, Union soldiers swept through Alabama, destroying the cotton mill, much of Scottsville and all of Scott's finances in March 1865. Union soldiers also commandeered Reverie, using it as a both sleeping quarters and offices. Financially, Scott was ruined. He died in 1868 penniless, except for the property that the mill used to sit on and Reverie, which he had gotten back in much worse condition than prior to the Yankees' visit. Eliza was left to care for the children and settle what she could of the estate. She auctioned off Reverie in 1871 for the price of $4,650. Her task complete, Eliza went back north to, ironically, another place bearing the name of Marion: Marion County, Illinois.

Marion businessman Harrison H. Hurt is the man who purchased Reverie at auction for his family home. He and his second wife, Annie, had a beautiful daughter named Nellie, who caught the fancy of a young doctor of whom her father did not approve. Hurt viewed Dr. R.C. Hanna as a bit of a showoff, too concerned with dressing well and riding the best horses to be a good husband. Despite her father's concerns, Nellie was determined to marry Dr. Hanna, and her mother was obliged to help her. Her father did not attend the wedding, which was held next door to Reverie in the Presbyterian church. Instead of walking his daughter down the aisle, Hurt, who was used to making unquestioned decisions, opted to hoe his garden, just outside where the ceremony was taking place. Guests, hearing the click of Hurt's hoe, worried that he may burst into the church to stop the ceremony. In the end, their beseeching of the preacher to expedite the vows was unnecessary, as Nellie and Dr. Hanna were successfully married in an uninterrupted ceremony.

Dr. and Mrs. Hanna enjoyed a happy, successful marriage as he built a lucrative medical practice in Perry County. In 1912, Dr. Hanna purchased Reverie and moved Nellie back into her childhood home, along with their seven-year-old daughter, Marion. Reverie was a lively place then, full of love, as well as dogs, cows, horses, hogs and the woman who helped make it all possible, Annie Hurt. Now known as "Granny," Annie was a widow who quickly became a central figure in the Hanna household. It must have been a difficult day for all, when on June 23, 1917, Nellie passed away for reasons we don't know. Granny did her best to care for Dr. Hanna and the

Reverie

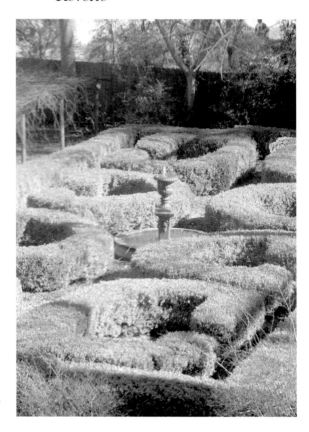

Reverie's outdoor knot garden
or maze, January 2009.

household after her daughter's death, but it was little Marion who is said to
have rescued her father's heart, introducing him to an attractive teacher at
her school, Alleyne Wallace.

The engagement was short and the wedding grand and memorable, for
many reasons. The elaborate ceremony was held in the bride's hometown
of York, at the Methodist church just across the street from her home. As
Alleyne was standing outside the church preparing to walk in, her family's
dog and pet bear began playing, roughly, in the family's yard. The bear
slapped the dog—a fox terrier, who then got even by chasing the bear. The
frightened animal ran to the first refuge it saw—Alleyne—climbing up her
leg as she was standing outside the church, poised to walk down the aisle.
After comforting the bear and sending it back across the street, Dr. Hanna
and Alleyne were married. Despite yet another nontraditional wedding
ceremony for Dr. Hanna, the marriage was, again, a joyful one. Alleyne
Hanna put her tasteful decorating skills to work, refurbishing Reverie. The

Reverie's plasterwork, January 2009.

home's new mistress added a tennis court, renovated the interior and exterior and landscaped the gardens—adding the outdoor living room that still exists today. She loved assuming the role of hostess in Reverie and entertained often. Tragically, as with Dr. Hanna's first wife, Allayne died before her time, in 1944, much to the dismay of all of Marion. This time, Dr. Hanna would not find another love; he died less than a year later.

Reverie then passed into the hands of the Hannas' daughter, Dorothy Jane Hanna Edmonds, who, in 1947, sold it to Dr. William Weissinger. He had grown up in south Perry County, and upon retirement from an illustrious medical career, he was ready to return home. Prior to purchasing Reverie, Dr. Weissinger served in the Army Medical Corps for three decades, including in France during World War I, commanding a regional hospital in Texas during World War II and then a tour as surgeon of the National War College in Washington, D.C. Dr. Weissinger and his wife Sudie Lee Knight of Uniontown fell in love with Reverie. She is credited with christening the house as Reverie, a name that means "quiet," "serene" and "lovely." Until this point, the home had been known as the Hanna-Weissinger Home. After

Jack and Jackie Woods, present owners of Reverie, January 2009.

the Weissingers' deaths, Sudie in 1962 and the doctor in 1970, Reverie changed hands several times, thankfully always to someone who left it better than they found it.

In 2005, retirees Jack and Jackie Woods of Heflin, Alabama, happened to walk through Reverie's doors on a lark. Jackie, originally from Talladega, grew up admiring and touring antebellum homes. One day she noticed an ad in the paper advertising an antebellum home in Perry County. The couple went to look, just for fun, but as they walked through the front door, Jack told his wife, "Honey, I think we're home." Reverie's draw was certainly powerful. The Woods family was well established in Heflin: Jack had served as the town mayor for two terms, and the couple owned a newspaper called the *Cleburne News*. Jack Woods witnessed Governor George Wallace's famous stand in the schoolhouse door at the University of Alabama and years later, as a newspaper owner, often took issue on the editorial pages of his paper with Governor Wallace's run for president.

The town of Heflin was shocked when the Woodses announced that they were moving to Marion to live in an antebellum home. "This is where

we're supposed to be. You don't just pick up at our age and move off. This is a dream come true, more than we ever imagined. We wanted another adventure. We just weren't ready to sit in our rocking chairs and watch the world go by," says Jackie Woods. Adds Jack, "Times changed, and we changed with them."

The couple has filled Reverie with family antiques and memorabilia from Heflin and thrown themselves into civic life in Marion, often using Reverie as a staging ground for meetings and fundraisers. Reverie's lush grounds—the knot garden, the vineyard (with its muscadine and scuppernong), the fountain, the old smokehouse and, of course, the wisteria vine that has seen it all—are a constant favorite among locals, which is just fine with the Woodses. "The people here are so welcoming and warm and open. It felt like home quickly in so many ways," says Jack Woods. The Woodses are doing their part to further improve Reverie, especially its grounds, the greenhouse and the conservatory. "She's a grand old lady, and she's holding up splendidly," says Jackie Woods with a smile.

Chapter 15

KIRKWOOD

Eutaw, Greene County, 1860

K irkwood is an opulent yet gracious example of an antebellum town house, an elaborate character in the prewar landscape, though not as well known as its sister plantation house. Antebellum town homes generally belonged only to the very wealthy—those who could afford to have a fine farm mansion crowning their plantation fields and then a separate and even more ornate home in town for entertaining and weeks spent away from the farm. A planter's town home often sat just a few miles away from his plantation property.

Kirkwood is such a town home, a true treasure whose value is amplified by the historic happenings it has witnessed through the decades. Cotton baron and merchant Foster Mark Kirksey commissioned the home in 1858, which was essentially completed in 1860, although the war interrupted the addition of such finishing touches as the home's iron railings on the second story. Much of his story survives today thanks to the pen of one of Kirkwood's later owners—Roy Swayze, who spent nine years researching Kirksey and then told his story in an essay titled "Foster M. Kirksey: A Black Belt Planter of Greene County." Swayze writes:

> *The portrait which has emerged shows a large man who perceived his home and his community in terms of Tennyson's Camelot. He saw himself a mannered gentleman and an honorable businessman, self perceptions which were shared by many other Southern men of that time from Virginia to Texas.*

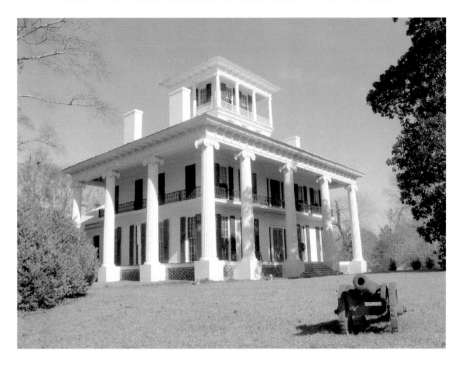

Kirkwood Mansion, January 2009.

The self-perceptions were indeed realities. Kirksey was certainly adept at business: in 1858, he owned 166 slaves, two plantations in Greene County and split time between his offices in Mobile and Eutaw. Although not born into a genteel family, Kirksey made up in actions for what he lacked in lineage. A later search of Kirksey's library revealed inspirational books lauding the ultimate gentleman and manners, such as Mark Girouard's *The Return to Camelot: Chivalry and the English Gentleman* and *Idylls of the King* written by Alfred, Lord Tennyson.

In the late 1850s, Kirksey and his wife Jane decided to build their dream home just off downtown Eutaw, which at that time was a bustling hub of culture—offering parties, parades, picnics and highly regarded private schools. The Kirkseys bought ninety-seven acres that flaunted a low area perfect for a lake, as well as high ground in the middle where the magnificent home would perch, surrounded on all sides by lush gardens. The couple sketched out a glorious Greek and Italianate four-story mansion that showcased lavish columns that wrapped around the side of the home instead of just the front, spacious windows, porches and a crowning cupola

Kirkwood

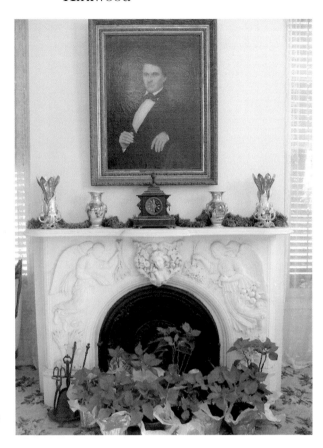

One of Kirkwood's exquisite Carrara marble mantels, January 2009.

providing a view of the entire property. As construction began in 1857, Jane Kirksey died. Her husband threw himself into the work of completing their dream home, his Camelot. Kirksey spared no expense, right down to the marble mantels carved in Italy and the crowning cupola that stands eighty feet high, seven stories off the ground.

In 1859, just months away from completing the home, forty-three-year-old Kirksey turned his attention to finding a bride. A petite twenty-year-old just home from Mme. Desrayoux's French finishing school in New Orleans named Margaretta Liston caught Kirksey's eye. In his essay, Swayze writes:

> *She could play the piano, sing and converse in three of the romance languages. Although he was 23 years her senior, this could be overlooked since she so perfectly filled the role of the demure medieval maiden. Mr. Kirksey dispatched his servant boy with a note to the young lady: "Mr.*

Kirksey sends his compliments to Miss Liston and requests the honour of her company tomorrow evening for a buggy ride."

Miss Liston accepted, and a few months later, her father gave his permission for his daughter to marry Kirksey. The couple wed on February 8, 1860, and moved into the almost complete Kirkwood mansion. Surely the newlyweds must have entertained grand ideas of what life would now be like in their beautiful new home. If so, they were daydreams that quickly flickered out as the harsh realities of the Civil War swept across the South, invading every crevice of life and spirit. Many of Eutaw's brightest and bravest never came home. Those who did manage to struggle back down the town's streets were shadows of themselves—thin, ragged and defeated. The elegant finishing touches for Kirkwood would never arrive: the gilded mirrors and crystal chandeliers from Paris, as well as the cast-iron balcony railing that Yankee soldiers turned back from delivery after taking control of the port of Mobile. It's a seemingly inconsequential detail when considering the war's cost, except that Foster and Margaretta's youngest daughter, Margaretta Eliza, was confined to a wheelchair. In 1909, at the age of twenty-nine, she rolled off the unprotected balcony, falling to her death—one more painful scar that the Kirkseys and the South would have to endure.

The Union troops also took command of Kirkwood for a while, using the Kirkseys' wedding bed as the sleeping quarters for General Benjamin Grierson and the home's parlor as a Yankee office to administer the new loyalty oath to area landowners. The folks of Eutaw might have had to submit themselves to this treatment, but they certainly didn't have to do it cheerfully. Notes from Anna Braun, a relative who lived at Kirkwood for a time, detail two amusing exchanges proving that the South's strength was crushed but not its spirit. One day a Union soldier scooped up the Kirkseys' young son, Liston, and asked him if he could whistle "Yankee Doodle." The indignant child straightened his back to sternly rebuke the soldier, declaring that he most certainly could not, as he was a Southern gentleman. Another day, a man arrived at Kirkwood to see General Grierson and take his oath of loyalty, carrying with him his own book on which to place his hand. After the oath had been administered, an inspection of the velvet covered book revealed it was not a Bible, but a book of Shakespeare. Grierson resigned himself to letting the man leave, reasoning out loud that no one in town meant a word they uttered anyway when taking the loyalty oath.

Kirkwood

Kirkwood's balcony without the rails, 1935. *Courtesy Library of Congress, Prints & Photographs Division, HABS, Alex Bush. ALA, 32-Euta-1-3.*

Through the next half century, the Kirkseys managed to hold on to Kirkwood despite the difficult economic times. The lovely town home passed into the hands of Foster and Margaretta's descendants, including Dr. H.A. Kirksey. In 1972, Washington, D.C. attorney Roy Swayze and his wife, Mary, made Kirkwood's acquaintance. By that time, there were no more children's feet romping through the halls or elegant mistresses tending to the home's needs. Instead, Kirkwood sat unoccupied, with vegetation growing over its crumbling exterior, dust and cobwebs covering the Kirksey family portraits and furniture that still sat inside. Swayze writes of this first meeting:

> *When a favorite teacup falls and breaks, one's first response is to pick up the pieces and attempt to fit them together. That best describes the feeling I experienced in 1972 when I first saw Kirkwood…I had this overwhelming urge to put it all back together with my own hands…as I looked I realized I was seeing unhealed war wounds, still fresh and bleeding…There was no way I could walk away.*

The Swayzes left their comfortable life and home in Virginia to spend the next fifteen years piecing Kirkwood back together again. They undertook a massive restoration and preservation project that experts estimate would cost about $8 million today, including installing an upstairs balcony railing that is true to the period. Swayze did much of the work himself, often learning as he went from local experts, like an older black gentleman simply referred to as "Odolph" in the notes that Mary Swayze carefully kept about all of the folks Kirkwood enabled them to meet.

One such acquaintance was famed Neoclassical architect Edward Vason Jones, who is responsible for renovations to the White House during the Nixon, Ford and Carter administrations. He appeared on Kirkwood's doorstep one day, offering his help with the restorations, wanting to ensure that the home's integrity was protected, at times going so far as to warn the Swayzes that they were "destroying" the home with some of the decorations and additions they had planned to do before Jones's intervention. It was the kindling of a deep friendship that would allow Jones's talented eye to guide much of the work at Kirkwood and lead to an invitation for the Swayzes from Jones to attend the Greek Revival Jeffersonian Reception at the State Department, where the Swayzes met Henry and Nancy Kissinger.

Fate provided the Swayzes with other unique opportunities for completing the restorations. Kirkwood was one of the filming locations for the 1979 movie

Kirkwood

Jaws of Satan starring Fritz Weaver, Jon Korkes and Gretchen Corbett. Mary writes about how producer Joel Douglas (credits include *Romancing the Stone* and *One Flew Over the Cuckoo's Nest*) and director Bob Claver (credits include *The Partridge Family*, *The Facts of Life* and *Charles in Charge*) landed a helicopter on Kirkwood's front lawn when courting the home as a filming location. In return for the use of the home, the studio unfortunately introduced snakes to the property, but fortunately painted the inside of Kirkwood, recovered furniture, varnished floors and stained doors once filming was complete. Kirkwood is a physical testament to the Swayzes' dedication in ensuring that it lived on, but several experts across the country gave official nods to the Swayzes' efforts as well.

In 1982, Roy Swayze was nominated for an award from the National Trust for Historic Preservation in the United States, and today the Alabama Historical Commission still hands out the annual Swayze Award to someone or some organization committed to preserving the past. Also in 1982, Swayze wrote a fifty-eight-page manual on how to care for Kirkwood, complete with numerous drawings and detailed explanations of elements such as the columns, water system and doors. Swayze adds, "Kirkwood is a fragile and irreplaceable artifact of the antebellum era. Its classic architecture and original furnishings will confer upon it ever increasing rank as a significant remnant of the southern Planter's Society."

Roy Swayze died in 1987, and Mary, unable to keep up with the home herself, sold it. From 1998 to 2001, Mary Vallides ran a bed-and-breakfast out of Kirkwood, until it finally fell into foreclosure. That's when Al and Danky Blanton of Jasper stepped in to save it and carry on the Swayzes' work.

In a way, Roy Swayze was an icon to Blanton. "He was a true renaissance man, the man," says the present owner of Kirkwood. The Blantons are committed to keeping Kirkwood architecturally pure and to sharing their treasure with the world. "Every day we get people coming up on the porch, taking pictures, wanting to know if they can see inside. We always tell them, 'Of course,'" says Al Blanton. Kirkwood is certainly a sight to behold. Not only is it one of the most photographed antebellum homes in Alabama, but the Blantons have also filled it with an art and antique collection worth an estimated $5 million, including beautiful furnishings covered in Scalamandre, a fine French fabric. One of Blanton's favorite features to show guests are the eight Carrara mantels from Italy, especially the fabulously ornate one in the parlor showcasing the "Goddess of the Seasons." Michelangelo's *David*

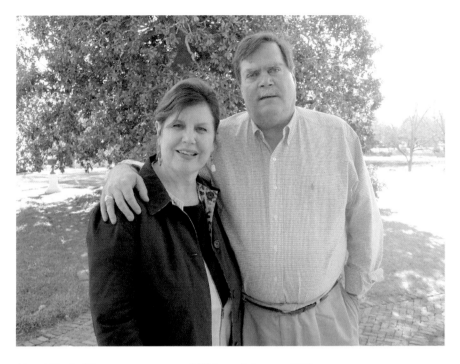

Al and Danky Blanton, past owners of Kirkwood, January 2009.

is also carved out of Carrara marble. "I like to say Michelangelo walked all over my marble several hundred years ago," laughs Blanton. The Blantons live at Kirkwood full time. Although some might think it tiring to have a daily parade of visitors, it's a duty that the Blantons are proud to welcome. "It's not just a house. It's something you respect. It's almost like Kirkwood is a living being. We're nothing but temporary caretakers. Kirkwood is bigger than any one person," says Blanton.

In 2009, the Blantons sold Kirkwood to Norris and Rebecca Sears.

Kirkwood was added to the National Register of Historic Places on May 17, 1976.

KENWORTHY HALL

Marion, Perry County, 1860

S tanding in commanding contrast to its white-columned contemporaries, Kenworthy Hall is a massive red, tan and brown Italianate villa mansion that is as wondrously functional as it is impressively beautiful, achieving the exact balance that its builder was striving to reach.

Edward Kenworthy Carlisle was the Georgia-born son of a doctor. He moved to Perry County with his mother, Susan Curry Carlisle, after his father died. Mrs. Carlisle had family members who were successful planters in Perry County and offered to take her in, as well as her son. Upon his arrival, Edward Carlisle set about the business of learning all that he could about being a cotton planter from his relatives. Although Carlisle went on to use that knowledge to run Kenworthy Hall's 440-acres of cotton fields, he made his true fortune in the 1840s and 1850s as a cotton factor—essentially the middle man between other planters and the textile industry.

Harold Woodman gives us an idea of what the job of a cotton factor entailed in his book *King Cotton and His Retainers*. Woodman paints a picture of men who were crucial to the economic process, whose intelligence and prior planning could make or break clients, who were often family and friends. Carlisle worked out of the port of Mobile with cotton buyers in New York, Liverpool and Le Havre, establishing a reputation as an ethical and dependable businessman. Carlisle strived to secure the best wholesale price for his clients' cotton, as well as tend to other business they had at the port, such as the ordering and delivery of luxury goods. Woodman writes that most cotton factors also served as a source of loan money for planters who needed cash in the off season to buy more land or slaves. The cotton factor charged a 2.5 percent interest rate and

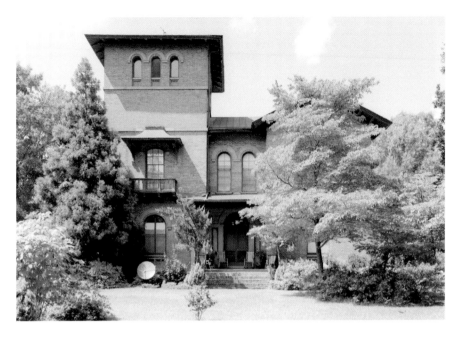

Kenworthy Hall, 1937. *Courtesy Library of Congress, Prints & Photographs Division, HABS, Alex Bush. ALA, 53-Mari. V-5-27.*

deducted what was owed from the profits of the planter's next cotton crop. These were the terms accepted not through written agreements but rather simply a gentleman's word and honor..

After splitting time between the port city of Mobile and Marion for years, amassing a fortune, Carlisle and his wife, Lucinda (Lucy) Wilson Walthall Carlisle, decided to build a proper home befitting their status on their Marion plantation property. In the late 1850s, Lucinda Carlisle's brother, Leonidas Walthall, recommended that Carlisle commission the architect who had just finished designing Walthall's home, known as Forest Hall. On May 4, 1858, Carlisle took his brother-in-law's advice and contacted famed New York architect Richard Upjohn to design a home gloriously unique yet practical to the point of luxurious for those times. Carlisle wrote, "Desiring to build a house, a country residence, and at a loss for a plan, we address you as a well known architect to ask you to draw us a plan, a rough sketch at first, which we hope may result in a suitable plan."

Upjohn's asymmetrical Italian-style villa was quite popular in the Northeast; his Edward King House in Newport is now on the list of National Historic Landmarks. Carlisle wanted to use that model but alter it for the southern

climate. According to Carlisle's letters to Upjohn, he wanted a home made from "only the finest materials," the best construction, simplest design and "all with the greatest economy." The resulting four-story mansion was made out of New York brownstone and Alabama bricks, with impressive skylights that captured the eye but were placed more for the illumination and air flow they created. Kenworthy Hall's numerous, variously shaped windows were chosen for more than just aesthetic purposes. Upjohn strategically placed them, along with the home's crowning tower, to create a wind tunnel powerful enough that, when all the windows are open, the hot air in the home is sucked out of the tower's hinged casement windows. Perhaps more impressive than the home's clever features is the fact Upjohn never laid eyes on his design in action. He and Carlisle designed the home strictly through letters, and as construction was underway, Upjohn solved problems and offered explanations via the same means of correspondence. Master mason Philip Bond actually supervised the daily work on site.

Kenworthy Hall boasts a thirteen-foot-wide main hallway, enormous rooms complete with closets and dressing rooms, three staircases, exquisite plasterwork in the Ladies Parlor and even a library with built-in bookcases whose detail perfectly matches that on the adjacent windows. Carbide gaslights were part of Kenworthy Hall's original design, powered courtesy of the carbide gas plant on the plantation grounds. Although the light would be dim by today's standards, the Carlisle family nonetheless enjoyed light on demand. Back then, the tower housed silk worms, which gave the family a wealth of precious material for fine clothing. Today, locals will tell you that Carlisle's daughter's ghost haunts the tower, for it is the place where she spent every day during the War Between the States, waiting and watching for her fiancé to return home. Legend says that the day she saw his servant coming up the drive alone, she threw herself down the stairs to commit suicide, knowing that he was gone.

Kenworthy Hall and the town of Marion, with its many classic antebellum structures, survived the Yankees' destructive hands. Some locals say its because Kenworthy's Italianate architectural design was so rare in the Deep South that when Union forces saw the top of the Hall's tower, they decided that it must have been a fort, a very large fort, which they didn't have time to handle. Legend goes that the Northern troops skirted Marion, keeping a safe distance from the large "fort" guarding the town.

The war itself did not financially hurt Carlisle. Records from his business, Carlisle and Humphries, show that Carlisle made money during the war years

Left: Kenworthy Hall's grand staircase, 1937. *Courtesy Library of Congress, Prints & Photographs Division, HABS, Alex Bush. ALA, 53-Mari. V-5-61.*

Below: Interior of Kenworthy Hall's tower, January 2009.

as the price of cotton sky rocketed, but after the war, it was a very different story. Carlisle belonged to the class of Southern men whose taxable property value was more than $20,000; he was therefore legally disenfranchised. Although President Andrew Johnson eventually pardoned Carlisle, after noting that he favored secession and aided Confederate soldiers' families, the world of business in the South was forever drastically altered. Property values plummeted—including Kenworthy Hall's, which was appraised at just $9,000 in 1871—and the planters who managed to survive no longer needed big loans or someone to arrange for the purchase of luxury goods. In the new South of tenant farmers and local merchants, there was little need for a cotton factor.

Carlisle was determined to adjust. Along with his son, Edward Kenworthy Carlisle Jr., and his son-in-law, Alexander W. Jones, he not only established a new partnership in Selma, but also made sure, in 1871, that all three were among the founders of City National Bank. Two years later, in January 1873, Edward Carlisle died at sixty-three years old. His wife, Lucinda, who had held the deed to Kenworthy Hall since the end of the war, spent the next forty years splitting time between Kenworthy and a home in Selma. Her daughter, Augusta Carlisle Jones, loved her childhood home so much that she returned to Kenworthy Hall's tower bedroom for the birth of all of her children. In 1899, Lucy Carlisle gave Kenworthy Hall to Augusta Jones. Carlisle died in 1912, and two years later, Augusta Jones sold Kenworthy Hall.

From 1914 into the 1950s, Kenworthy Hall weathered a rough storm of absentee owners and vandals and was eventually abandoned. In 1957, a century after construction on the home began, a Birmingham woman by the name of Karen Klassen bought the property and nineteen acres for $4,000. This signaled the turn in Kenworthy Hall's fate. Klassen spent ten years repairing mantelpieces, doors and plaster. In 1967, she passed the torch on to Heber and Nell Martin, a Mormon couple with twelve children, who seemed to count the house as their thirteenth charge. The Martins spent three decades restoring Kenworthy to its former glory. Heber Martin did much of the work himself, including repairing the magnificent and often-photographed spiral staircase that the servants had used to stay out of sight in the main house. It twists from the whitewashed cellar to the third floor. The entire Martin family cherished the home so much that locals renamed it the Carlisle-Martin House. Martin was retired from the phone company and created a working farm out of the estate's acreage, raising cows and pigs and growing sugar cane and various vegetables. The family

Kenworthy Hall's detached kitchen and walkway, 1937. *Courtesy Library of Congress, Prints & Photographs Division, HABS, Alex Bush. ALA, 53-Mari. V-5-21.*

considered Kenworthy a community treasure and often opened its gates to organizations desiring to use the grounds for events. In 1997, the Martins allowed the Historic American Buildings Survey to spend the entire summer photographing, documenting and sketching the estate.

Shortly afterward, both of the Martins died, and their children, despite their passion for the home, were unable to move home and care for the house. In 2001, James and Nancy Pigg of Tennessee purchased it, and then, in October 2006, sold it to the present owner, Tashery Ottway Smithers of Florida. The listing price was $950,000.

Today, Smithers's exquisite Arabian horses roam Kenworthy Hall's pasturelands. The home's original separated kitchen, carriage house (which may have served as a smokehouse, though no one knows for sure) and cistern live on, next to a mansion that has survived radical historical changes yet is all the more precious for the experience.

Kenworthy Hall was added to the National Register of Historic Places on August 23, 1990, and designated as a National Historic Landmark in 2004.

WHITE COLUMNS

Camden Vicinity, Wilcox County, 1860

N estled in the Possum Bend area of Wilcox County, White Columns is a true treasure, both because of its architectural significance and its meticulously kept history that gives us a unique glimpse back in time at a plantation life that was lost long ago.

James Asbury Tait and his wife, Caroline Elizabeth Goode, moved to the Black Belt about 1815 before Alabama became a state (December 14, 1819). The Taits quickly became one of the wealthiest families in Wilcox County, owning the second largest number of slaves, 377, compared to Mark Pathway's 438. James Tait's journals provide some insight into how slaves were treated, at least the ones in the Tait family. Tait writes that he personally saw to the needs of his slaves, rebuilding cabins for them in new locations every few years and burning the old ones—likely to avoid disease—and hiring a doctor whose sole job was to care for the Tait slave population. Tait says that everyone on his plantations received new clothes, including shoes, twice a year, come spring and fall. Tait writes about how he strived to provide a healthy, balanced diet to his slaves, including meat, flour, sugar and vegetables. Wilcox County Probate Office records show that Tait did not believe in selling slaves because they were part of the family, and he strongly discouraged the practice among family members who stood to inherit the slaves after Tait was gone.

When James Asbury Tait's death drew close, he provided plantation land and the finances to build grand homes on that property to each of his eight children, including his flamboyant fifth child, Major Felix Tait, who received three thousand acres of land and forty-one slaves from his father's estate.

Major Tait, who served during the Mexican-American War and in the Confederate army, met Narcissa Goree while she was attending the Marion Female Seminary (now Judson College) with his sisters, Martha, Julia, Rebecca and Sarah. Her father, originally from Louisiana, gave his blessings in a strong French accent for the couple to be married once his daughter finished her studies and Tait completed his at the University of Alabama. The couple married on September 10, 1850, in Perry County.

In the late 1850s, Major Tait commissioned master architect Alexander Bragg to build a grand home for his wife and their growing family, which eventually numbered fifteen—thirteen children and Major and Mrs. Tait. This home would become known as White Columns.

Wilcox County is filled with historic antebellum homes, the second-largest number in the state just behind Mobile County. Of the ones in Wilcox County, White Columns is the youngest, by five to ten years, just as Major Tait planned. Ever the colorful center of attention, the major wanted his home to best all the others in the county, so he waited to see what everyone else would build during the construction rush of the late 1840s and the

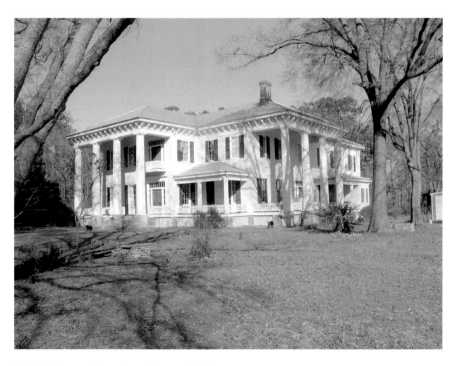

White Columns Plantation, February 2009.

White Columns

1850s. The smallest of developments could ignite the major's competitive spirit as he was designing his home—things such as a neighbor hiring a traveling artist to adorn a parlor ceiling with moons and stars.

Major Tait hired Bragg to build his home while Bragg was completing the Wilcox County Courthouse, which is still in use today. Bragg and Tait modeled White Columns after the courthouse's Eclectic design, where classic Greek Revival and Italian features were combined. Bragg used mostly local materials to build White Columns: the longleaf pine trees from the grounds for timber and bricks for the home's foundation and its six fireplaces (three chimneys) came from the Camden brickyard. Sand and hair from the plantation's horses and mules (from manes and tails) were combined to create the necessary plaster.

White Columns was built to exact, carefully checked specifications; one can still see the corresponding Roman numerals carved into door frames, doors, windows and window casings, ensuring that every one met its specific mate. White Columns' grand mahogany staircase arrived via steamer from Mobile, and a sophisticated gutter system decorated with eagles and stars drains rainwater off the white oak shingles covering the home. Eight massive

View west from White Columns' front balcony, 1936. *Courtesy Library of Congress, Prints & Photographs Division, HABS, Alex Bush. ALA, 66-Cam.V-7-7.*

Doric columns frame the house, which are made from twelve-inch-wide unspliced pine logs. White Columns has eighteen rooms and two central halls, as opposed to the traditional design of one hall and eight rooms. Plaster crown molding highlights the fourteen-foot ceilings; however, there are no ornate ceiling medallions, likely because the Civil War ended Tait's decorating process. The parlor doors still wear their original finishes. The home's two-story detached kitchen matched the main house, right down to the two Doric columns supporting the hipped roof. Food was prepared on the first story; the second story was where the house servants lived. There was also a dairy house, a grand smokehouse and even a twelve-seat privy (outhouse), which the current owner, Ouida Starr Woodson, can remember using as a little girl because of curiosity rather than necessity. None of these outbuildings survives today, yet they do live on in Woodson's memory.

Locals in Wilcox County say that when Narcissa Goree Tait finally got to walk into her plantation home for the first time, she used her wedding ring to etch her name onto one of the windows. Despite her signature claim to White Columns, she would only enjoy the home for twenty years. Her husband, Major Tait, was a boisterous man who believed that money was for spending and risks for taking. As the conflict leading up to the War Between the States began to take shape, Major Tait contacted rifle craftsman Samuel Colt to custom design a set of pistols that the major intended to first purchase for himself and then later to arm his entire company of Confederate soldiers. White Columns' history shows that Major Tait paid for his personal set of pistols but never made the larger order for the men under his command. (There is a collector who has visited White Columns, explaining he now owns Major Tait's custom-made pistols. He has in his possession Tait's original 1860 letter specifying the pistols' design and capabilities, as well as other correspondence pertaining to the weapons.) Perhaps Tait's desire to see his men properly outfitted is where one of the stories detailing how the Taits lost White Columns originates: Felix and Narcissa had a daughter named Julia Zimmerman who married Samuel William McDowell of Liberty Hall plantation, also located in Wilcox County. Their granddaughters, Sara Harris and Mary Gogbold, still have a portrait of Narcissa Goree Tait hanging in Liberty Hall. They remember hearing a story of how Felix Tait lost his plantation because, as the War Between the States raged on, Major Tait became deeply concerned about his soldiers' lack of clothing.

The legend says that Tait mortgaged and subsequently lost his plantation to borrow enough money to buy his men decent uniforms to keep them warm

White Columns

White Columns' arbor, 1936. *Courtesy Library of Congress, Prints & Photographs Division, HABS, Alex Bush. ALA, 66-Cam.V-7-13.*

in the winter months. White Columns' history has a different explanation: mirroring the developments in much of the South, Wilcox County's economy was decimated after the end of the War Between the States in 1865. Large, wealthy landowners like Major Tait saw most, if not all, of their wealth erased overnight, and in 1868, taxes on their land began to skyrocket, as carpetbaggers moved in to take advantage of the financial situation. Ouida Starr Woodson explains in the history that she wrote of her home:

> *For ten years, Wilcox County was under the control of the carpetbaggers and their scalawag cohorts. Here the scalawags were among the previously wealthy and Major Tait was among their number. These men called themselves "Independents" and made alliances with several of the Carpetbaggers in order to keep their lands as well as their political positions. Major Tait returned to the Legislature in Montgomery during these years, as did his brother-in-law Dr. Robert Hugh Ervin.*

White Columns' history says that in 1873, Englishman Samuel Tepper lent Tait $5,000, with White Columns and its acreage serving as collateral.

The two men supposedly never agreed on a payment schedule, payoff date or interest charges. However, Tait allegedly never made a payment, purportedly losing the entire loan betting on a cockfight. In 1879, Tepper's daughter, Molly, married Dr. Lucius Starr of Bibb County. Tepper, wanting his daughter to stay in Wilcox County, offered the newlyweds White Columns if they would agree not to move to Bibb County. The Starrs accepted Tepper's offer; he foreclosed on Tait, paying him an extra $3,000. The Starrs moved into White Columns in January 1880, and their descendants have owned the home ever since.

Felix Tait died in 1899, remembered as a dedicated husband, father, soldier and statesman. His wife Narcissa died in March 1907 at the home of her daughter, Mrs. W.N. Bragg.

The Starrs made the house their own by filling it with children and a collection of beautiful furnishings and personal items, many of which remain inside the home today. Of course, the old plantation system was just a memory at that point, so the Starrs embraced the new sharecropping system that replaced it. The Starrs allocated a certain portion of White Columns' land for sharecroppers (often former slaves) to grow their own cotton crop, usually advancing seed and fertilizer to the sharecropper as well. The tenant farmers were also often given homes and enough ground to plant a garden for their own use. In exchange, the sharecropper owed some of his harvest to the plantation owner, and oftentimes the deal required the sharecropper to spend time working in the owner's fields as well. At the end of his first year of ownership, Dr. Starr had seventy sharecropper families living on White Columns' acreage. Now that plantation owners such as him were no longer responsible for providing their former slaves with clothes, medicine or food, Dr. Starr followed the example of many other landowners and, in the early 1890s, opened a plantation commissary or store, where sharecroppers could purchase staples. He razed the old two-story kitchen and built the new store in its place. Dr. Starr was a busy man, also serving as the community doctor for Possum Bend and the surrounding communities.

In 1918, White Columns passed into the hands of Dr. Lucius and Molly Starr's son, Paul, Ouida Starr Woodson's grandfather. The sharecropping system was still in place, with approximately fifty families now residing on the plantation property. Woodson's first memories of White Columns begin in the 1950s, when the number of tenant farmers had dropped again, to around thirty. Cattle were now the main revenue generator for White Columns, although cotton was still being grown. Woodson recalls:

White Columns

I remember cotton being planted on about 300 acres. In the spring, all members of the plantation community worked in the fields to plant and cultivate the cotton crop. In the fall, the same was true as the cotton was picked. I well remember my own hoe, specially made for me by one of the men which I used to chop cotton. I also remember my cotton sack which my MaMa [grandmother] made for me to use to pick cotton. It wasn't very big, but I thought I was quite something as I filled the sack and Granddaddy weighed it in order to know how much I would be paid at the end of the week.

Woodson's memories of race relations at White Columns are happy ones. She says that her grandfather and great-grandfather were always available to members of the community, black or white, but especially to the sharecroppers who were part of White Columns' community.

To the black families that lived on the place, Dr. Starr in his day and "Mista Paul" in his were there to help in times of need or to celebrate in time of happiness. I remember many times as a child being awakened by some activity in the house. Some person from the place had come to the back door with a tale of illness and needing Granddaddy or Daddy to "go get Dr. Paul" or a tale of one of the people being "put in jail" by "Mista Lummie," the County Sheriff. Granddaddy or Daddy would get up and make the trip to town to either carry the person to the doctor or go get him, as well as make many trips to see Mista Lummie. When I was a little girl, I had free run of this entire place. Every little distance was a house filled with children and caring adults who loved me as their own and I loved them back just as well. I could go to any house and my parents and grandparents feel secure in my safety. Many times, I would stop for a drink of water or a meal. I had a whole variety of children to play with, and we genuinely enjoyed each other's company. My Granddaddy would let me go everywhere with him and play and visit. I was taught from an early age to measure the character of the person as opposed to the color of his skin. My experience was not too different from most of my contemporaries.

When Paul Starr died in 1958, only ten sharecropper families lived at White Columns, a stark sign of the change that was just around the corner. In the 1960s, the southern agrarian lifestyle wilted, and people moved away from the land. Today, there are no sharecroppers at White Columns. Not a single one of their homes remain on the property as evidence of this page in history.

White Columns' smokehouse, 1936. *Courtesy Library of Congress, Prints & Photographs Division, HABS, Alex Bush. ALA, 66-Cam.V-7-9.*

After Paul Starr's death, White Columns passed into the hands of his son, John Paul Starr, who was married to Lois Evelyn Arnold of Birmingham. They lived at White Columns for more than half a century before John Paul died in 1992, followed by Lois in 2000. At that time, the home went to their daughters, the fourth generation of Starr ownership, including Ouida Starr Woodson, who is married to Sam. D. Woodson. The couple lives at White Columns today, surrounded by family memorabilia such as Molly Tepper's parlor set, another wedding gift from her father, who had it shipped all the way from California. Other treasures include engravings from famed London artist Joseph Mallord William Turner dating back to the 1830s (he was Samuel Tepper's cousin); Tepper's diary detailing his return to England in 1872; Bibles from the early 1800s; and a portrait of relative John Wesley Starr painted in the 1840s when he was serving Bibb and Perry Counties as a circuit rider for the Methodist church. John Wesley's father, Joshua Starr, was also a preacher and is credited with establishing the first permanent Methodist church in Georgia in 1803.

White Columns

This plantation home and the families who have lived in it have experienced much change in a relatively short period of time. Cotton is just a childhood reminiscence. Woodson and her sisters now use White Columns' remaining one hundred acres to grow timber. But like the White Columns mistresses who precede her, Woodson believes that the plantation's memories are worth sharing. White Columns has been receiving visitors and officially telling its story since the 1960s, when it became one of the stops highlighted in the *Alabama Tourist Guide*. Since then, the plantation home has been a featured favorite on numerous pilgrimages and home tours.

In 1976, White Columns was added to the Alabama Register of Historic Places.

EPILOGUE

Alabama's Black Belt is an area with a vivid past but an unclear future. This fertile strip of land never regained the wealth or importance that it enjoyed during the early to mid-1800s. After the War Between the States, the art and occupation of planting struggled to live on but by a different set of rules. A slim few plantation owners continued to operate under a tenant farmer arrangement or perhaps by hiring their previous slaves.

Slavery turned into tenancy farming, and many of the old relationships between owners and workers continued, albeit slightly altered. Yet the plump profits that had sustained an expanding and exploitative economic system that had built the genteel columned houses of popular imagination became a distant memory. Eclipsed by industrialization, growing economic diversification and the onset of corporate America, the planter way of life slowly waned. Following suit, the number of plantation farms has dwindled year after year.

Now, the Black Belt counties are some of the poorest in the country. U.S. Census Bureau statistics show the median income for a household in the Black Belt is $27,130. Per capita income for the region is $15,633. Job opportunities are scarce, and today's economic climate has challenged the survival of mom and pop businesses that were long stalwarts of the local economy. Once the wealthiest and most populated area of the state, less than two centuries later the region's population is declining as folks move on in search of better job opportunities, healthcare and education.

In 2000, 13 percent of Alabama's population lived in the Black Belt—just less than 590,000 people, but that number is expected to drop even further

in the 2010 census. In February 2009, Wilcox County's unemployment rate stood at 21.5 percent and Dallas County's at 18.5 percent, per statistics from the Alabama Department of Industrial Relations.

Today the descendants of many slaves still call the Black Belt home. Now, the name "Black Belt" refers to the racial composition of the region as much as it does the description of the soil. After the 2008 presidential election, some have begun calling the Black Belt the Blue Belt because of its overwhelming support for President-elect Barack Obama. The rest of Alabama was a solid red state, with the exception of Birmingham.

It is the fervent hope of many that through efforts like this book and many others, the Black Belt can once again find its niche in the world and grow back into a thriving, prosperous place to live. There is much to preserve here, much to learn from and, many believe, much yet to be offered to the rest of the world.

BIBLIOGRAPHY

Alabama Historical Commission. "Behind the Design—the People of Gaineswood." State of Alabama, n.d.

———. "Magnolia Grove." December 17, 2008.

Burnett, Emmett. "Haunted Hall." *Alabama Living* (March 2003).

Carmer, Carl. *Stars Fell on Alabama*. New York: Farrar and Rinehart, Inc., 1934.

Columbia Encyclopedia. 6th edition. New York: Columbia University Press, 2008.

Cooper, Chip, Harry Knopke and Robert Gamble. *Silent in the Land*. Tuscaloosa, AL: CKM Press, 1993.

Dubose, John Witherspoon. "Chronicles of the Canebrake." *Alabama Historical Quarterly* (Winter 1947).

Gamble, Robert, and Robert Mellown. Kenworthy Hall National Historic Landmark Nomination Form.

Gamble, William C. "The Shadow of John and Margaret deVane King Beck." Private essay written by family.

Glass, Mary Morgan. *A Goodly Heritage, Memories of Greene County*. Clarkville, TN: Josten's, 1977.

Hammond, Ralph. *Ante-Bellum Mansions of Alabama*. New York: Bonanza Books, 1951.

Harmon, David, comp. "Everhope Plantation."

Hatcher, Gregory, comp. "Reverie Mansion and Gardens, Genteel Memories," 2001.

Jones, Brock, comp. "Descendants of James Innes and Anne Amelia Smith Thornton." Program for 2000 Thorn Hill Reunion.

———. "Thorn Hill Plantation."

———. "The Thornton Legacy." Program for the 1995 Thorn Hill reunion.

Kirshner, Ralph. *The Class of 1861—Custer, Ames and Their Classmates after West Point*. Carbondale: Southern Illinois University Press, 1999.

McWilliams, R.E. Article concerning True Blues Flag. *Wilcox Progressive Era*, February 10, 1921.

Picton, Eliza Gould Means. "Reminiscences." Box #185, 7S, Alabama Department of Archives and History.

Richardson, Clive. *The Architects' Journal*. London: EMAP Ltd., 2005.

Riley, Reverend B.F. *History of Conecuh County, Alabama*. Greenville, SC: Southern Historical Press, 1998. First published 1881 by T. Gilbert Steam Printer and Book Binder.

Selma Times Journal. "Sturdivant Hall Attracting Tourist Crowds." June 7, 1965.

Stritikus, Gregory. "Rosewood." Southern Gardening Historical Society, 1986.

Swayze, Mary. Collection of notes concerning Kirkwood visitors. Located at Kirkwood.

Swayze, Roy. "Foster M. Kirksey: A Black Belt Planter of Greene County." Personal essay, located at Kirkwood.

Talbert, Doris, and the Sturdivant Hall Museum Association. "Sturdivant Hall."

The Upjohn Collection, New York Public Library. Letters between Edward Kenworthy Carlisle and Richard Upjohn, 1858–59.

Wilcox County Historical Society. Spring 2001 Newsletter. Camden, Alabama.

Wilcox County Historical Society. Spring 2007 Pilgrimage Brochure.

Williams, Linda. "Rosewood." Located at Rosewood.

Williamson, Betty Dale. "Wilcox True Blues." *United Daughters of the Confederacy* magazine, September 1986.

Woodman, Harold D. *King Cotton and His Retainers: Financing and Marketing the Cotton Crop of the South, 1800–1925*. Lexington: University of Kentucky Press, 1968.

Woods, Jack, comp. "Reverie." 2008. Located at Reverie.

Woodson, Ouida Starr. Brochure Woodson for the Wilcox Historical Society Fall Tour of Homes, September 1995.

———. "Within the Bend." March 10, 2000. Personal essay.

ABOUT THE AUTHOR

Jennifer Hale is a native of New Orleans who spent much of her childhood growing up in Mobile, Alabama. She developed a love for antebellum culture and history early in life as she split time between these two premier southern cities, especially when she served as a Mobile Azalea Trail Maid her senior year of high school.

Jennifer earned her undergraduate degree in political science and journalism from Louisiana State University and her master's degree in broadcast journalism from Northwestern University on a foray above the Mason-Dixon line.

Although since graduating Jennifer has worked full time as a television journalist, she has also greatly enjoyed freelance writing and photography projects. Before this book, Jennifer wrote a monthly travel column for *Country Roads* magazine out of Baton Rouge, featuring various south Louisiana cultural festivals and historic accommodations such as antebellum hotels and bed-and-breakfasts.

Jennifer currently resides in Birmingham, Alabama, where she is an award-winning anchor and reporter for the NBC affiliate. For more information, go to www.jenniferehale.com.

Visit us at
www.historypress.net

..

This title is also available as an e-book